Ambrose / Harris

COLOUR

n. the sensation
produced by rays of light
of different wavelengths,
a particular variety of this

ava | Academia
the environment of learning

AVA Publishing SA
Switzerland

An AVA Book

Published by AVA Publishing SA
Rue des Fontenailles 16, Case postale,
1000 Lausanne 6, Switzerland
Tel: +41 786 005 109 Email: enquiries@avabooks.ch

Distributed by Thames & Hudson (ex-North America)
181a High Holborn, London WC1V 7QX, United Kingdom
Tel: +44 20 7845 5000 Fax: +44 20 7845 5055
Email: sales@thameshudson.co.uk
www.thamesandhudson.com

For distribution in the USA and Canada please contact:
English Language Support Office
AVA Publishing (UK) Ltd.
Tel: +44 1903 204 455 Email: enquiries@avabooks.co.uk

English Language Support Office
AVA Publishing (UK) Ltd.
Tel: +44 1903 204 455 Email: enquiries@avabooks.co.uk

ISBN 2-88479-066-7
10 9 8 7 6 5 4 3 2 1

Design and text by Gavin Ambrose and Paul Harris
with the assistance of Ashley Sansom
Original photography by Xavier Young
www.xavieryoung.co.uk
Original book and series concept devised by Natalia Price-Cabrera

Production and separations by AVA Book Production Pte. Ltd., Singapore
Tel: +65 6334 8173 Fax: +65 6334 0752 Email: production@avabooks.com.sg

Colour

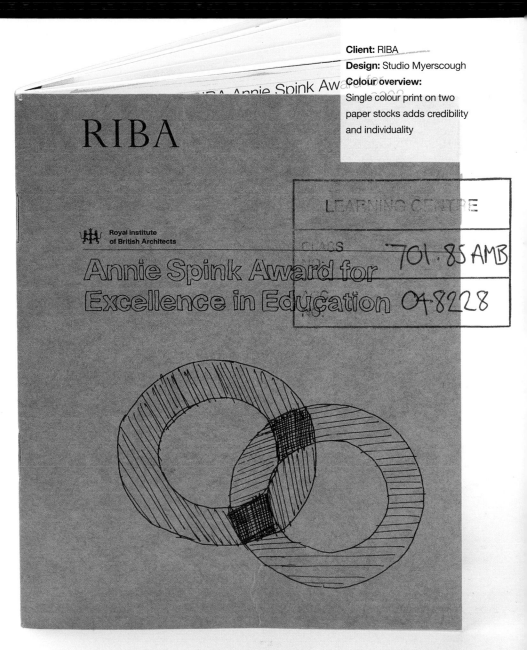

Client: RIBA

Design: Studio Myerscough

Colour overview:

Single colour print on two paper stocks adds credibility and individuality

RIBA: Annie Spink Award for Excellence in Education

This brochure was created by Studio Myerscough design studio for the Royal Institution of British Architecture. It is printed in one colour on a white paper stock, but the addition of a manila cover stock adds variety and interest. The single colour of the cover design enforces the impression that the typography and images have been hand drawn in pencil.

Contents

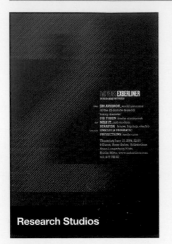

Research Studios

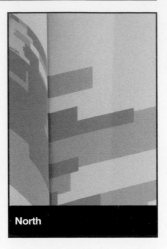

North

Gavin Ambrose

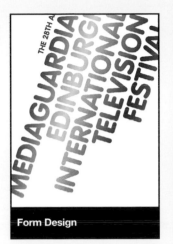

Form Design

Intro

Bis

Colour Contents

Introduction

Colour is the most immediate form of non-verbal communication. We naturally react to colour as we have evolved with a certain understanding of it, partly because the survival of our ancestors depended on it with regard to what to consume and avoid. Colour is used to represent thoughts and emotions in a way that no other element of design can, and it can act as an instant attention grabber whether in print, on screen or on a supermarket shelf. As such, colour is an important facet of contemporary design. We all, inherently, have preferences that inform our decisions when dealing with colour, and we are subject to all the cultural norms and understandings of colour usage that surround us.

The relative cheapness of four-colour printing means that colour is used for even the simplest print jobs. While serving a decorative function, colour also helps to isolate and identify distinct pieces of information and therefore is a key tool for initial information processing. Colour can be used to present strong graphic statements or provide more subtle support. Whatever the purpose, successful colour usage requires an understanding of colour systems, how these can be used, and the meanings that can be associated with the colours themselves. This book provides a background to these areas so that the designer can make informed colour decisions.

The Basics

This section provides an introduction to the basic principles and terminology of colour theory, including how colour works, the colour wheel, and different colour schemes.

Colour Systems

Here we introduce and explain the colour systems that a designer will use, including the variations between RGB and CMYK, as well as the different requirements for screen, web and print designs.

Using Colour

Colour can be used in many ways in graphic design. This section explores basic colour usage methods including four-colour printing, the use of tints and surprints, ink trapping, tones and gradients, and special colours.

Techniques

More experimental colour usage can be achieved through the use of a variety of techniques. This section looks at ways to colour images by altering values such as hue, saturation and contrast, and manipulating colour curves.

Colour Symbolism

Different colours have different cultural and emotional meanings that vary depending upon where you are in the world. This section explores what various colours mean and how they relate to emotions, which enables a designer to colour code information.

Colour in Practice

Colour can be used to impart specific information, this section explores some of the cultural meanings and symbolism that make colour such a strong communicator of important content.

Rachel
Whiteread
28.10.0

Client: Haunch of Venison
Design: Spin
Colour overview:
Attention grabbing
colour combination
juxtaposed with minimalist
white-on-white printing

Invitation

Haunch of Venison

This invitation by Spin design studio for a Rachel Whiteread exhibition, at the Haunch of Venison Gallery, has a simple and playful feel due to the clever use of colour. The garish treatment given to the artist's name, whose orange letters clash with the pink background they are set against, draws attention to the spartan message that comprises a name and a date. This loudness of the invitation contrasts with the minimalist outer envelope upon which the word 'invitation' is barely noticeable as it is printed white-on-white.

Minimalist

Minimalism was a school of abstract painting and sculpture that came to prominence in the late 1960s, which emphasised extreme simplification of form. It is non-representational and characterised by a severely restricted use of visual elements such as colour.

Colour Introduction

This book introduces different aspects of colour design via dedicated chapters for each topic. Each chapter provides numerous examples of creative colour use in design from leading contemporary design studios, annotated to explain the reasons behind the design choices made.

Key design principles are isolated so that the reader can see how they are applied in practice.

Clear navigation
Each chapter has a clear strapline to allow readers to quickly locate areas of interest.

Introductions
Special section introductions outline basic concepts that will be discussed.

Black

Black is quite simply the negation of colour. In Europe and North America, black has traditionally been the colour most associated with death and mourning. It is conservative and serious, and yet sexy, sophisticated and elegant. Exclusive events are often described as 'black-tie' and important dignitaries almost always travel in black limousines.

Black suggests opulence and exclusivity more than any other colour, and so it is associated with a gamut of luxury goods and used heavily in their promotion. The gravitas of black is also associated with weight and solidity, as the colour offers an imposing and powerful presence. For automobiles, the advantage is that black cars are perceived to be solid and therefore safer. Conversely, commercial airliners avoid painting their craft black as people would perceive the aircraft as too heavy to fly.

When used in conjunction with white or yellow, black offers the strongest contrast of any colour combination and is consequently one of the most powerful. Black works well with most colours with the exception of other very dark colours.

Client: The Crafts Council
Design: Cartlidge Levene
Colour overview:
Embossed black substrate used to suggest luxury and exclusivity

Solid Air (right)
This invitation was created by Cartlidge Levene design studio for an exhibition hosted by the Crafts Council in London. The prism graphic was used as a simple visual metaphor to represent light, colour, reflection and refraction. Information about the event is embossed into the black substrate to create a strong visual hook and impact a sense of exclusivity. The suggestion of exclusivity is enhanced by the luxuriously glossy surface of the invitation and the rarity of this manner of presentation.

Colour Colour Symbolism

Written explanations
Key points are explained within the context of an example project.

Examples
Commercial projects from contemporary designers bring the principles under discussion alive.

Additional information

Clients, designers and colour
overview principles are included.

Diagrams

Diagrams add meaning to
theory by showing the basic
principles in action.

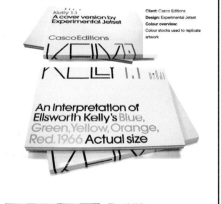

Spread from the book showing:

RGB

Red, green and blue are the additive
primaries that correspond to one of
the primary colours of light. Colour
reproduction on a television screen or
computer monitor is achieved via the
RGB colour system.

A designer generally captures, designs and manipulates an image using the RGB
colour system. If the design is to be printed, it is converted to the CMYK colour
system upon completion, which is required for the four-colour printing process. As
the CMYK colour system has four colours (rather than three), the file size increases.
Equally, a design that is to be printed using the Hexachrome system will be even
larger. If the design is to be posted on a website or other form of electronic media it
will remain in the RGB system.

To ensure that colour will reproduce as intended, the monitors and output devices
that a designer uses to produce work need to be colour calibrated.

These rows of images show the four channels of the CMYK system (top), and work with a white background,
and the three channels of the RGB system (bottom), which work with a black background. Both systems preserve
the colours of the original image (far left), and this means that the necessary conversion from RGB to CMYK for
four-colour printing will not result in any loss of colour quality.

Client: Xavier Young
Design: Gavin Ambrose

Xavier Young
Each of these web pages features a full colour photograph that is set against a black
background, into which white text has been reversed out. Websites and other
electronic media are typically produced in the RGB colour system.

Spread from the book showing:

Paper stocks

The use of different coloured paper stocks
provides an often overlooked method that
will add colour to a design, particularly
one that would otherwise be monotone.

Paper stocks are available in numerous colours and this provides a designer with
great versatility and the creative potential to combine many different types. When
printed, all but the darkest colour stocks can retain text legibility.

Stock selection can have a dramatic impact on colour reproduction. Some stocks are very absorbent and
as such give dull colours, whilst others have coatings that are designed to give high-quality colour
reproduction. This book uses gloss-, uncoated-, and kraft-paper stocks, all of which produce different
colour reproduction results. The table below outlines the suitability of different stocks for colour printing.

Stock	Characteristics	Colour reproduction	Use
Uncoated or offset	Highly absorbent, which means sharp colour images are difficult to reproduce	Good, but limited if sharp images are required	Magazines
Matt	Coated stocks that have a dull surface	Excellent, flat colour with low glare. Ideal for photorealistic images	Magazines, flyers, brochures, catalogues
Silk/satin/ semi-gloss	More coating than matte but less than gloss stocks	Excellent, low glare, ideal for photorealistic images	Magazines, flyers, brochures
Gloss	Coated paper with a smooth and high-white gloss surface	Excellent, ideal for reproducing bright colour	Staple of magazine production, brochures
Cast-coated	Heavy, clay-coated stock. Pressed (or cast), while still wet against a polished, hot, metal drum to produce a high gloss finish, usually on one side of the sheet	Excellent colour reproduction	Magazines, flyers brochures
Tracing paper	Translucent stock with little space between paper fibres. Low ink absorption, difficult to print on	Possible, but limited	Special projects
Tissue paper	Thin, highly-absorbent stock	Unsuitable	Not applicable

Kelly 1:1
A cover version by
Experimental Jetset

CascoEditions

An Interpretation of
Ellsworth Kelly's Blue,
Green, Yellow, Orange,
Red. 1966 Actual size

Client: Casco Editions
Design: Experimental Jetset
Colour overview:
Colour stocks used to replicate
artwork

Ellsworth Kelly
This book, which was created by
Experimental Jetset, is specifically
designed to display an interpretation
of Blue, Green, Yellow, Orange, Red –
a piece by American minimalist artist
Ellsworth Kelly. Kelly's work comprises
five monochrome panels: three are the
primary colours and two are their
intermediary colours: green and
orange. The book contains a full-scale
replica of the painting, which is
reproduced using different coloured
paper stocks that are bound together
into a single volume.

Related information

Related information such
as definitions are isolated
and explained.

Colour How to get the most out of this book

Client:

Imperial Records, Japan

Design: Form Design

Colour overview:

Limited palette of graduated colour fills create a playful sense of movement

COIL

New Single

2003.8.6 release
TECI-51
1,000yen (tax out)

New Album
LOVE

2003.9.3 release
TECI-1047
2,900yen (tax out)

COIL Tour
"LOVE LIVE"

2003.9.14 @ Shinsaibashi
Club Quattro
info. Greens 06-6882-1224

2003.9.18 @ Shibuya
Club Quattro
info. Flip Side 03-3470-9999

COIL official web
http://www.office-augusta.com/coil/

Imperial Records web
http://www.teichiku.co.jp/imp/

The Basics

Colour is perhaps the first element that we register when we view something for the first time. Our cultural development and conditioning mean that we will naturally make associations based upon the colours we see, and these provide an idea of how we should react to an object or design that incorporates them. Colours attach meaning, and our reaction to this will depend upon cultural associations, trends, age and individual preferences.

Colour is a key element of graphic design, a tool that can be used to attract attention, steer and direct the viewer, and inform them about the type of reaction they should have towards the information presented. This book introduces a number of basic concepts that relate to colour usage in graphic design, and show how contemporary designers use colour to bring their work to life. Such concepts include how colours can be combined in specific schemes in order to create a range of different moods.

This book uses specific terminology that relates to colour theory. It is important to understand these terms, as they facilitate effective communication between designers, printers and clients. Sometimes complex terms – such as value, hue and saturation – are all defined clearly and simply here.

Coil (left)

This promotional material was created by Form Design. It features a circular pattern that uses a predominantly blue colour palette and two graduated colour fills that surround the name of the band: Coil. One half of the fill combines the blue with yellow and the other half with magenta.

Colour codes

Colours can have a variety of embedded meanings, which can be linked to different emotions and moods.

As such, colours can be used to illicit a specific emotional reaction in the viewer. This spread summarises some of the common meanings that are associated with different colours, but this is not a universal guide because associated meanings will differ from country to country and within different cultures. The colours and their related associations presented below provide a starting point for linking colours to emotions, but creativity can transcend many of these associations depending upon how colours are used.

Scarlet red
Exciting, aggressive, dramatic and dynamic.

Brick red
Secure, natural and strong.

Warm red
Seductive, arousing and sultry.

Vivid pink / magenta
Passionate, flamboyant and attention grabbing.

Light pink
Sweet, delicate and feminine.

Dusty pink
Romantic, luscious, tender and sentimental.

Mauve
Serene, subtle and mellow.

Burgundy
Opulent, wealthy, intense and grand.

Fuchsia
Voluptuous, energetic, theatrical and fun.

Terracotta
Spicy, warm, ethnic and wholesome.

Orange
Fun, glowing and vital; the warmest of colours.

Peach
Healthy, soft, gentle, tactile and velvety.

Bright yellow
Hopeful, cheery, but also cowardly and deceitful.

Light yellow
Inspiring, warm, calming, hazy and summery.

Golden yellow
Sunny, autumnal, baked, but also a warning.

Green yellow
Citrus, acidic, fruity, tangy and sharp.

Cream
Dense, rich, clean, classical and simple.

Beige / taupe
Dependable, flexible, bland and timeless.

Brown
Wholesome, earthy, dependable and friendly.

Coffee / chocolate
Succulent, durable and delicious.

Fawn
Secure, practical, organic and rustic.

Lilac
Feminine, refined, elegant and graceful.

Lavender
Floral, scented, nostalgic and eccentric.

Purple
Sensual, futuristic and embracing.

Royal purple
Majestic, expensive and regal.

Plum
Full-bodied, plump sophisticated and unique.

Violet
Mysterious, fantasy, spiritual and floral.

Teal
Cool, expensive, confident and trendy.

Electric Blue
Dynamic, engaging, bold and exhilarating.

Navy
Uniform, reliable, safe, traditional and constant.

Royal blue
Committed, dramatic, professional and vibrant.

Sky blue
Relaxing, happy and trustworthy.

Turquoise
Healing, spiritual, mystical and exotic.

Baby blue
Cute, youthful, serene, quiet, cosy and subdued.

Aqua
Fluid, refreshing, cleansing and energising.

Dark green
Natural, organic, plentiful and luscious.

Light green
Rejuvenation, edible, but also nauseous.

Olive green
Classic, drab, muddy, and durable.

Khaki
Uniform, camouflage, military and resourceful.

Lime
Acidic, tart, refreshing, juicy and zestful.

White
Purity, innocence, goodness and clinical.

Gold
Wealth, extravagance, excess, luck and tradition.

Silver
Prestigious, grand, cool and metallic.

Bronze
Warm, tradition, durable and rustic.

Black
Magical, dramatic, elegant, sinister and bold.

Charcoal
Sophisticated, sober and professional.

Cool grey
Spartan, reputable and miserable.

Warm grey
Contemplative, worldly and sober.

Client: Whatman

Design: Still Waters Run Deep

Colour overview:

Vibrant orange on white,
exudes warmth and goodness

Where Whatman?

The Laboratory
Whatman has a supreme position in the Laboratory:

- In Education.
- In Research.

- In Quality Control.
- In Healthcare.

- In Forensics.

- In Genomics.

- In Proteomics.

- In Environment:

- In Defence:

In Schools and Universities
In Pharmaceuticals,
Biotechnology and
in Industry generally.
Across Industry.
In Hospitals, Clinics
and in the Community.
In the Justice system,
Immigration and the Police.
In the Purification and
Storage of Nuclear Acids
In the Purification
and Storage of Proteins.
In Air Pollution control,
Water and Wastewater
quality.
In Homeland Defence
and the Armed Forces

The requirements for separations generally, and filtration in particular, are increasing daily. Where there is a laboratory bench, there is the familiar Whatman Blue Box. In many laboratories worldwide, where the product is volume filtration, it refers not to a filtration specification, but to a 'Whatman No. xx'.

Analytical Chemistry
Whatman is one of the best known brands in the vast and disparate analytical chemistry market. We focus on several key market areas: Pharmaceutical, Biotechnology, Environmental and the Food and Beverage Industry. In addition to both University and Government research where our products are designed and manufactured for laboratories undertaking research, analysis and quality control. Whatman products are used in sample preparation, as devices for purification, isolation and identification of substances in fluids and as a component in process manufacturing.

In Pharmaceuticals and Biotechnology, Whatman solutions are used at almost every stage of the drug development process, including research and development, chemical constituent testing, screening and efficacy analysis. Whatman has made sample preparation easier, faster and more efficient with innovative products such as the MiniUniPrep syringeless filter – a unique, easy to use, combined filtration and storage device – and the GD/X syringe filter that makes difficult samples easy to filter. With products ranging from syringeless filters for laboratory samples to large scale ion exchange and chromatography papers for quality control in drug manufacture, Whatman solutions are essential. From water, air and exhaust emissions to nuclear radiation and weapons of mass destruction, Environmental

Whatman's filtration and separation products ensure bacteria-free food and beverages

Client: British Council

Design: Intro

Colour overview:

Green is used to warm the conservative blue, to produce a cool result

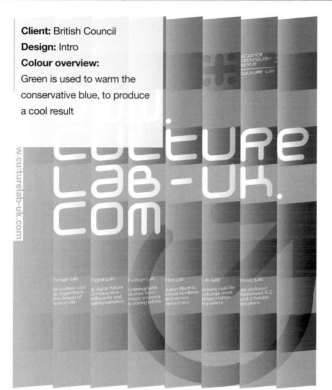

Culture Lab (this page)

These posters were created by Intro design studio for a British Council awareness campaign called Culture Lab. The British Council promotes British science, education and contemporary culture. While blue is generally considered a somewhat conservative colour, here it is warmed by the use of green. This creates a cool, youthful feel that complements the tritone photograph of the band: Radiohead.

Inside Out (left)

This spread is taken from a corporate brochure, which was created by Still Waters Run Deep for laboratory products developer Whatman. The vibrant orange colour provides a sense of vitality and, together with the water splash, imparts a feeling of well-being and goodness. The dash of orange brings instant warmth to the design and serves as a particularly attractive contrast to the largely white background.

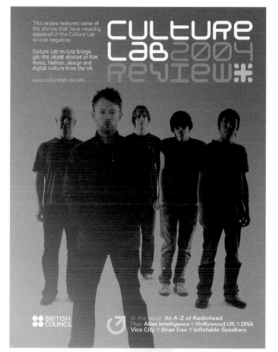

Colour Colour codes

Basic terminology

There is a great deal of complex terminology that surrounds colour and its usage. Here, we clarify basic colour theory and explain its affiliated terms.

Primary colours

There are in fact two different types of primary colours: additive and subtractive. The additive primaries are those colours that are obtained by emitted light. Red, green and blue are the additive primaries, and all three colours combine to produce white. Subtractive primaries are those associated with the subtraction of light. Cyan, magenta and yellow, the process colours used in four-colour printing, are the subtractive primaries. These three colours combine to produce black.

Secondary colours

From each set of primary colours, a secondary set of colours can be produced. A secondary colour is created by combining any two primary colours in equal proportions. In the subtractive colour space the secondary colours produced are red, green and blue. In the additive colour space the secondary colours produced are cyan, magenta and yellow.

Tertiary colours

These are produced by combining a secondary colour with the remaining primary colour, which is not already present in the secondary. This is equivalent to mixing subtractive primary colours in the proportions 2:1 or 1:2.

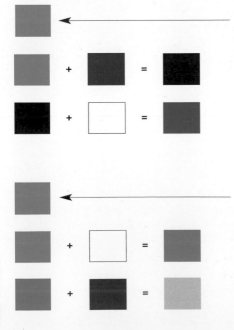

There are three subtractive primaries. In this example we use one: cyan.

Cyan is combined with another subtractive primary (magenta), to produce a secondary subtractive colour (blue).

The secondary colour (blue) is combined with the subtractive primary colour not already present in the mix (yellow), to produce a tertiary colour (blue-purple).

Again, in this example cyan is still the subtractive primary

Cyan is combined with another subtractive primary (yellow), to produce a secondary subtractive colour (green).

The secondary colour (green) is combined with the subtractive primary colour not already present in the mix (magenta), to produce a tertiary colour (yellow-green).

Subtractive primaries and colour assimilation

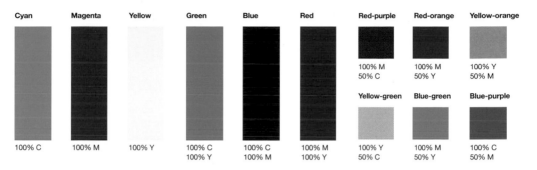

Cyan	Magenta	Yellow	Green	Blue	Red	Red-purple	Red-orange	Yellow-orange
						100% M 50% C	100% M 50% Y	100% Y 50% M

						Yellow-green	Blue-green	Blue-purple
100% C	100% M	100% Y	100% C 100% Y	100% C 100% M	100% M 100% Y	100% Y 50% C	100% M 50% Y	100% C 50% M

In the examples opposite, the secondary colours of blue and green are mixed with the primary colours of yellow and magenta. However, this page is printed using the four-colour process (CMYK), and it is not possible to mix additive and subtractive primaries in four-colour printing. Therefore, the correct tertiary colour must be created by mixing different ratios and combinations of additive primaries. For instance, mixing 100% cyan (C) and 50% magenta (M) will assimilate blue-purple, which produces the same result as mixing the secondary colour blue with the primary colour yellow, as shown in the first example on the facing page.

Additive primaries

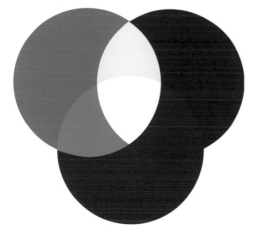

Subtractive primaries

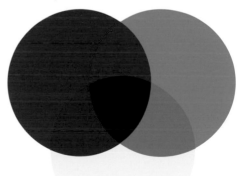

This diagram shows the additive primaries. Where red and green overlap, yellow is created. Magenta is formed where red and blue overlap, and cyan is created where blue and green overlap. These secondary colours are the subtractive primaries. Each additive primary represents a component of white, so where all three colours overlap, white is produced because all the components are present.

This diagram shows the subtractive primaries. Each of the these has one of the additive primaries missing. Where two subtractive primaries overlap, only one additive primary is visible. Blue is formed where cyan and magenta overlap. Cyan and yellow overlap to produce green. Magenta and yellow combine to form red. Where all three subtractive colours overlap, black is produced because no light escapes.

Colour Basic terminology

Describing colours

Every colour corresponds to a unique light wavelength, but a list of different wavelength values does not provide a particularly useful description of a colour.

Similarly, the names of different colours have descriptive limits: what does dark red actually mean? Hue, saturation and brightness are values that are often used to describe colour in greater detail.

Saturation →

value ↕

Hue / colour

Hue, or colour, refers to the unique characteristic of a colour that helps us visually distinguish one colour from another. Hues or colours are formed by different wavelengths of light.

Saturation / chroma

Saturation, or chroma, refers to the purity of a colour. As the diagram above demonstrates, saturation levels describe a colour's tendency to move towards or away from grey. At maximum saturation a colour contains no grey, such colours are described as vivid, bright, rich, full and so on. At lower saturation levels, the colours contain increasing amounts of grey, which result in subdued, muted and dull colours.

Value / brightness

Value refers to how light or dark a colour is. Changes in value can be achieved by mixing a colour with different proportions of white or black. A colour that is mixed with white is called a tint (see page 74), while those mixed with black are called shades. Value is not to be confused with saturation as the two are independent.

The colour wheel

Pictured below is a circular representation of the colour spectrum, which is known as the colour wheel. It serves to explain the relationship between different colours and is an essential part of colour theory. The colour wheel also illustrates the classification of colours, providing a quick reference to the primary, secondary and tertiary hues, and this can help a designer successfully select systematic colour schemes. Colours can be described as warm or cool and help a designer to set a particular mood. The use of the colour wheel can be seen in more detail on the following spread.

Warm

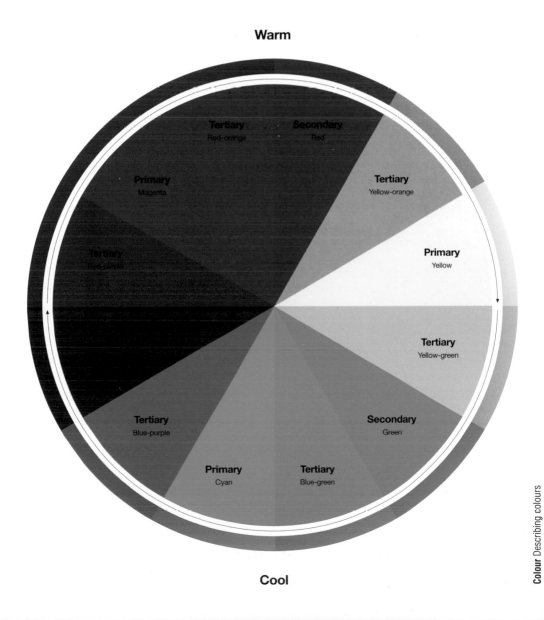

Cool

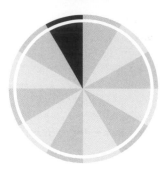
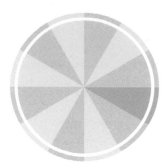

Monochrome

A monochrome colour is any single colour on the wheel.

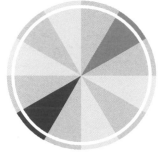
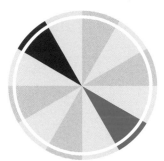

Complementary

Complementary or contrasting colours are those that face each other on the colour wheel. Complementary colours provide a strong contrast, so their use will result in a more vibrant design.

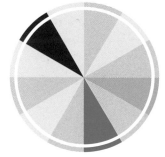
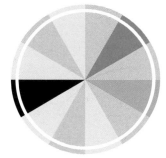

Split complements

Split-complementary colours comprise three colours. These are the two colours adjacent to the complementary colour of the principal colour selected.

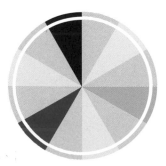

Triads

Triad colours are any three colours that are equidistant on the colour wheel. As all three colours contrast with one another, a triad colour scheme provides a tension to the viewer. The primary and secondary colour spaces are both triads.

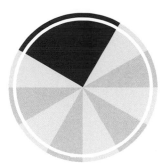
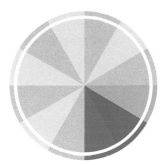

Analogous

Analogous colours are the two colours on either side of a selected principal colour, so essentially, any three consecutive colour segments. Analogous colour schemes provide a harmonious and natural blend of colours.

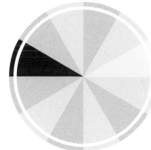
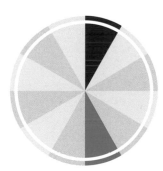

Mutual complements

A set of mutual complements comprises a triad of equidistant colours, and the complementary colour of the central one of them.

Near complements

A near complementary colour is one of the colours adjacent to the complementary colour of the principal colour selected

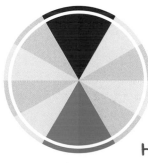

Double complements

Double complements are any two adjacent colours and their two complements, which will appear on the opposite side of the colour wheel.

Colour Colour wheel selections

TWO YEARS **EXBERLINER**
THE ENGLISH-LANGUAGE PAPER FOR BERLIN

live **JIM AVIGNON**_world premiere
of the 25-minute musical
"funny disaster"
DIE TÜREN_berlin electrorock
djs **MILK IT**_anti-modern
STARFISH_ house, hip hop, electro
visuals **UMEDULA PRISMATIC
PROJECTIONS**_melbourne

Thursday June 10, 2004, 22:00,
6 Euros, Roter Salon, Volksbühne,
Rosa-Luxemburg-Platz,
Berlin Mitte, www.exberliner.com
tel: 473 729 66

Exberliner

These posters were created by Research Studios as part of a redesign project that
coincided with the second anniversary of English-language newspaper *Exberliner*.
Each poster is dominated by a contemporary colour scheme derived from

Client: Exberliner
Design: Research Studios
Colour overview:
Graduated contemporary
colour scheme based around a
single colour

TWO YEARS **EXBERLINER**
THE ENGLISH-LANGUAGE PAPER FOR BERLIN

live **JIM AVIGNON**_world premiere
of the 25-minute musical
"funny disaster"
DIE TÜREN_berlin electrorock
djs **MILK IT**_anti-modern
STARFISH_ house, hip hop, electro
visuals **UMEDULA PRISMATIC
PROJECTIONS**_melbourne

Thursday June 10, 2004, 22:00,
6 Euros, Roter Salon, Volksbühne,
Rosa-Luxemburg-Platz,
Berlin Mitte, www.exberliner.com
tel: 473 729 66

Colour Colour wheel selections

complementary colours on opposite sides of the colour wheel. The graduated
application of the colour works with an even lighter tone that is used for the dominant
'2', which produces a very harmonious effect.

Colour combinations

The colour wheel is a tool that can be used to select harmonious combinations of colour for a design. Colours chosen from different points on the wheel will provide a variety of complementary colours, analogous colours, or mutual complements (a triad of equidistant colours and the complementary colour of the central one).

Selecting a colour combination that works will depend largely on the message that is to be conveyed. In any design, a dominant colour that is supported by subordinate and accent colours can usually be found. Colours tend to generate a specific response or association from the viewer, and so an understanding of these reactions will help a designer to create effective colour combinations that will enforce their intended message.

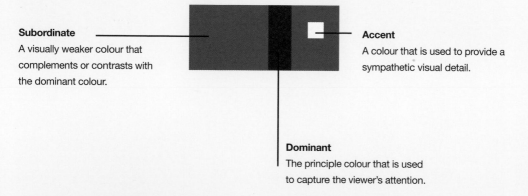

Subordinate
A visually weaker colour that complements or contrasts with the dominant colour.

Accent
A colour that is used to provide a sympathetic visual detail.

Dominant
The principle colour that is used to capture the viewer's attention.

Becks Futures (right)
Research Studios designed this outer packaging, which was used to hold the supporting documents for the Becks Futures art prize. In this design, brown is used as the dominant colour, yellow is the subordinate colour and white and orange are used as accent colours. This is a subtle and natural range of colours, which are soft and non-intrusive.

Client: Becks Futures
Design: Research Studios
Colour overview:
Natural colour combination
with brown (dominant), yellow
(subordinate), and white and
orange (accents)

Colour Colour combinations

Client: Roger Fawcett-Tang
Design: Struktur Design
Colour overview:
Vibrant complementary colour
combination

Roger Fawcett-Tang

This calendar was
created by Roger
Fawcett-Tang and used
as a promotional device
to send to his clients.
The page shown
features a vibrant orange
background colour, which
combines with a vivid
pink to form a bold
number '13'. Used with
a more subdued colour
palette, or with a white
background, both of
these colours would be
overpowering. However,
used in combination,
as they are here, they
complement one another
and temper any vivacity.

Calm

This palette uses light to mid-tones of blue, green and lavender, which can be contrasted with white or off-white. Conjuring images of clear blue skies, and crystal waters lapping gently, this palette reflects tranquillity and peace. The colours are quiet, unassuming and serene.

Natural

These warm, earthy colours are rich in tone, autumnal and reflect the outdoors. Leafy greens, woody browns, berry reds and oranges contribute to this palette, which also draws on golden tones and violets to further enhance the feeling of rustic charm.

Mystical

Full of intensity and mystery, this palette has an enigmatic quality. Blues, purples and greys stretch beyond reality and transcend to the outer realms of the imagination. These colours exude energy and suggest different forms of magic, spirituality and religion.

Pastel

Pastels create diffused colour that is subtle and delicate, allowing for experimentation with a variety of combinations. Pastels blend cool and warm shades easily. This palette can express youthful innocence, immaturity, vulnerability and romance.

Bold

A powerful palette that uses black combined with one or two authoritative colours such as deep blue or vibrant yellow. Like the warning markings displayed by animals and insects, these colour combinations undoubtedly make a statement.

Vibrant

Think of a carnival and try to emulate it in colour. It is likely to be loud, unrestrained and flamboyant. There is energy and activity in this palette, which is created with mainly warm colours. Bright and vivid tones produce a childlike quality.

Refined

These colours bring to mind fine wine and rich textiles via a palette of traditional colours that create associations of wealth. It draws on middle-class Victorian interiors for inspirational hues with a sense of grandeur. Powerful colours that lean towards black may be combined with cream, greys or metallics for contrast.

Neutral

This palette uses natural, primitive colours with an organic aura – reminiscent of the natural world. The sometimes drab grey or neutral cream can be enlivened with fawn and green. This palette offers a simplicity that works in many applications and can be successfully exhibited alongside other muted colours.

Refreshing

This palette is clean and crisp with precise strokes of colour that cool, refresh, cleanse and revitalise. Imagine a brisk summer breeze or a splash of chilled water. Like a foaming azure sea, deep blues can be contrasted with pure white. The hint of a blue-green tone will add warmth to the primary colours.

Colour Colour combinations

Colour Systems

Client: Orla Kiely
Design: Solar Initiative
Colour overview:
Intricate colour detail that
mimics design characteristics
of the client

Designers have a selection of colour systems and frameworks to work with. The selection of a particular colour system will often depend upon how the final design is to be produced and / or presented, as different systems possess different limitations and options. It is important to recognise and understand that a final design needs to incorporate the appropriate colour system for its intended use

Two of the most widely recognised and commonly used colour systems are RGB (red, green and blue), and CMYK (cyan, magenta, yellow and black). RGB is typically used for digital publishing and initial designs, and CMYK is used for print publishing. An awareness of the limits of different colour systems allows the designer to produce work safe in the knowledge that it will be reproduced accurately and as intended.

Additionally, the six-colour Hexachrome colour system has two more colours: orange and green. This produces a larger gamut of colours than the basic four-colour CMYK printing process.

Special process colours can also be used to provide precise colour control and intense graphic effects, for example, through the use of fluorescent and metallic colours. Special colours may be applied via a separate printing plate or by replacing one of the standard process colours. While ensuring accuracy of a given colour, the incorporation of a special colour changes the overall gamut of colours that can be produced.

Orla Kiely Brochure (left)

This brochure for Orla Kiely's Spring / Summer 2005 fashion collection, was created by Solar Initiative. Orla Kiely is known for her exceptional use of colour, and this has been reflected in the brochure design. Intricate colour detail can be seen on the page shown; text lines are printed in various muted colours and in blocks that create a pattern of houses. The text reads 'I found I could say things with colour and shape that I couldn't say in any other way – things I had no words for.' The elements on the page summarise the designer's clothing and accessories range and also mimics a fabric print she often uses.

Gamut

The gamut describes the spectrum of colours that a particular system, device or process can reproduce.

Design tools such as scanners, monitors, software applications and printing processes all work with different colour spaces. These colour spaces will define the range, or gamut, of colours that are at the designer's disposal. Using colours at the fringes of the gamut will mean it is difficult to ensure that they remain faithful to the original design if they are transferred from one device to another.

In this diagram, the red line represents the Hexachrome gamut, the blue line represents the RGB gamut, and the green line represents the CMYK gamut. The outer black line denotes the spectral colour gamut. RGB displays approximately 70% of the colours perceived by the human eye, and CMYK even less. The six-colour Hexachrome process adds orange and green and this serves to increase the gamut.

Hexachrome

The Hexachrome colour system describes a six-colour separation process that was developed by Pantone in 1994, and which produces more effective purples, greens, oranges and flesh tones for accurate, vibrant and saturated colours. The Hexachrome system adds orange and green to the CMYK process colours. Hexachrome can reproduce 90% of the Pantone PMS colours; this is quite a contrast to CMYK, which can reproduce approximately 50% of the Pantone PMS colours.

Client: Syn Records
Design: North
Colour overview:
Use of metallic silver and green special colours, which cannot be produced by the standard CMYK gamut

Nick Wood **Sound Virus**

Sound Virus

This CD packaging was created by North design studio for Nick Wood's 'Sound Virus' album. It features metallic silver and fluorescent green special colours that cannot be produced within the standard CMYK gamut.

Colour Gamut

CMYK

A printed colour image is typically produced using four different printing inks: cyan, magenta, yellow and black.

These inks correspond to the three trichromatic colours, which are produced by the colour separation process and are necessary to reproduce colour images, and black. Black is represented by 'K' meaning key. Nearly all colours can be printed using a combination of these subtractive primaries in the four-colour printing process. Theoretically, the CMY inks can produce black, but in printing practice a separate and 'true' black ink is used to add depth to elements such as shadows.

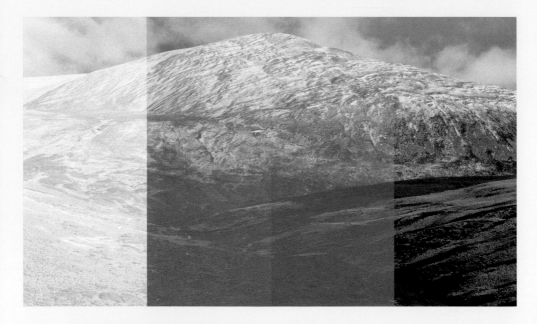

The four-process colour inks are applied by separate printing plates in the C, M, Y and K sequence in order to build up an image. In the above example, notice the effect that the final black plate has on shadow and contrast.

The CMYK process colours cannot reproduce all colours. This green block has been produced using the CMYK colours, but it lacks the vibrancy of the special colour that was used to print the opposite page. If you examine this block closely you will see it is made up of halftone dots – unlike the solid colour used on the opposite page. The extra vibrancy is one of the main reasons that special colours are used when colour is of paramount importance.

Using 100% cyan produces a flat colour, with no dot gain.

Using 100% magenta also produces a flat colour, with no dot gain.

Values of 16% cyan, 79% magenta, 59% yellow and 0% black produces a flat solid colour.

Values of 18% cyan, 8% magenta, 22% yellow and 0% black produces a lighter, more subtle colour.

A solid, primary red can be produced by printing solid magenta and yellow.

A colour will look clean if the values are high enough to produce a solid colour. Here 50% cyan and 50% magenta give a clean purple colour.

Values of 62% cyan, 85% magenta, 64% yellow and 39% black produce a muddy colour.

High aggregate values produce similar colours. This similarly coloured chip has values of 80% cyan, 86% magenta, 86% yellow and 0% black.

Values of 5% cyan, 5% magenta and 5% yellow combine to produce a light tint.

The four-colour printing process can produce a wide range of colours, but there are a few points to remember. Each CMYK ink can be applied with a value ranging from 0% to 100%, a single colour is therefore expressed as the percentages of each ink. For example cyan is 100% cyan, 0% magenta, 0% yellow and 0% black.

The total of these percentage values should not exceed 240, if they do it will result in muddy colours (as shown above in the bottom row). Conversely, very light shades are difficult to achieve because the colours 'drop off', or fail to register when printing. Colours generally reproduce best if they contain a reasonably solid amount of any one colour.

RGB

Red, green and blue are the additive primaries that correspond to one of the primary colours of light. Colour reproduction on a television screen or computer monitor is achieved via the RGB colour system.

A designer generally captures, designs and manipulates an image using the RGB colour system. If the design is to be printed, it is converted to the CMYK colour system upon completion, which is required for the four-colour printing process. As the CMYK colour system has four colours (rather than three), the file size increases. Equally, a design that is to be printed using the Hexachrome system will be even larger. If the design is to be posted on a website or other form of electronic media it will remain in the RGB system.

To ensure that colour will reproduce as intended, the monitors and output devices that a designer uses to produce work need to be colour calibrated.

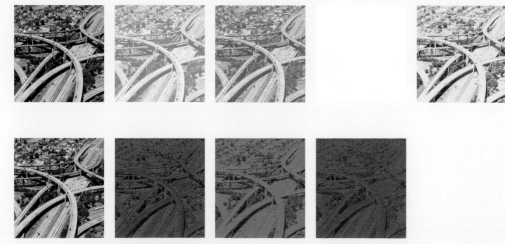

These rows of images show the four channels of the CMYK system (top), which work with a white background, and the three channels of the RGB system (bottom), which work with a black background. Both systems preserve the colours of the original image (far left), and this means that the necessary conversion from RGB to CMYK for four-colour printing will not result in any loss of colour quality.

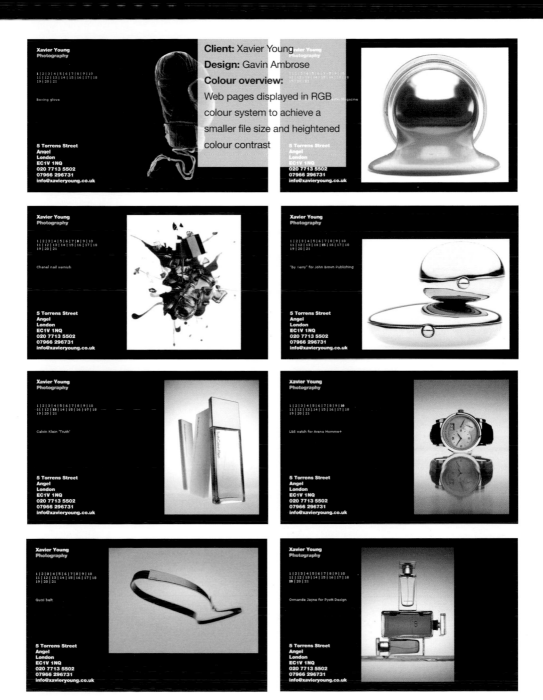

Xavier Young

Each of these web pages features a full colour photograph that is set against a black background, into which white text has been reversed out. Websites and other electronic media are typically produced in the RGB colour system.

Special-process colours

Although the four-colour printing process can produce a wide range of colours it is sometimes desirable to use a special-process (or spot) colour, which is a specially made ink.

A special colour is one that is solid, rather than composed of dots and as such it is richer and more vibrant than the nearest corresponding process colour mixture – as can be seen below. Special colours are also used to produce metallic tints and fluorescent colours, which are out of the gamut of the standard four process colours. These colours are used when it is of paramount importance to reproduce a strong, accurate colour – one common usage is for corporate logotypes.

Special colour	CMYK colour
Pantone 802	C 51.8% M 0% Y 80.4% K 0%

The left hand rectangle is printed as a fluorescent green special colour and its nearest CMYK version is printed on the right. The process-colour rectangle is much duller as it is made with halftone dots of colour, whereas the special colour version is applied as a flat colour.

Land Registry (right and following spread)

This is a corporate identity guide for the Land Registry, which was created by North design studio. It is a four-colour brochure that uses special colours instead of the standard CMYK process colours to provide a palette of natural colours which reflect the function of the Land Registry. The four special colours used are PMS 377, PMS 396, silver and black.

The use of these colours meant that all the images incorporated in the brochure (see following spread), had to be modified so that they would print correctly with this colour palette. Replacing process colours with special colours is a more complex affair than simply swapping them. The colour levels (the depth of each colour), of the images, must be individually adjusted so that they reproduce accurately and as the designer intended.

Client: Land Registry
Design: North
Colour overview:
Four-colour litho printing, using
special colours PMS 377,
PMS 396, silver and black

Multiple covers
Each cover is printed with one of
the four printing inks, and all are
wrapped around the block of the
publication.

Colour coding

A colour-coded index system maximises the usage of each colour.

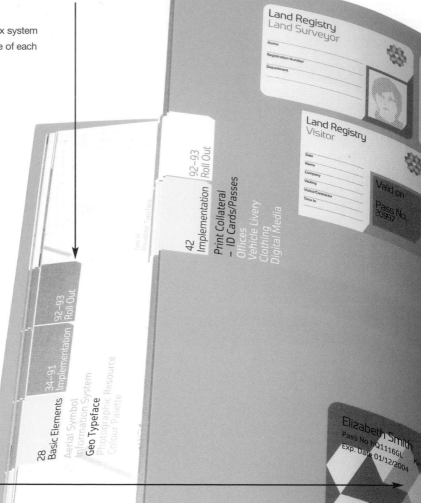

Tints

Tints, or different colour values, are used to increase the number of available colours that can be used in the design.

Halftone

The simulation of a continuous tone by a pattern of dots.

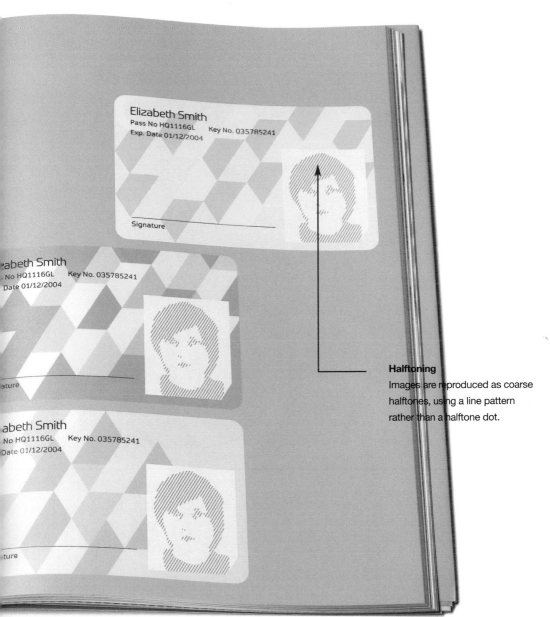

Halftoning

Images are reproduced as coarse halftones, using a line pattern rather than a halftone dot.

Fluorescents

Fluorescents are special colours that have a particular vibrancy and cannot be produced using the standard four-colour process inks. Fluorescent colours demand attention, although over use within a design can be tiring on the eye.

Special colours, including fluorescents, are normally applied via an additional and separate printing plate when four-colour printing is used, although if a design uses a limited colour palette, the special can replace one of the other printing plates.

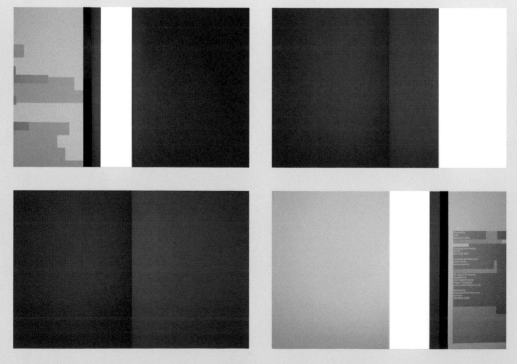

Client: G&B Printers
Design: North
Colour overview:
Fluorescent and CMYK inks
printed on a metallic-gold
paper stock

Not Just CMYK (above and left)

This is a brochure created by North design studio for G&B Printers to demonstrate
some of the company's printing capabilities. It features a number of different
fluorescent colours, in addition to the CMYK process colours, which are printed on to
a gold metallic cover stock.

The brochure features a series of arresting and vibrant spreads and tipped-in pages
that use fluorescent colours. For example, the spread that incorporates full-bleed
fluorescent pink and orange colours (shown bottom left on the facing page), provides
a dynamic sensation of movement.

Colour Fluorescents

Fourth Estate (this page)

The cover of this catalogue, created by Rose Design for publisher Fourth Estate, is printed with a green spot colour. On the catalogue's interior pages, the spot colour is used to highlight certain text elements such as book titles. This works on two levels; it allows the key information to stand out and also echoes how a student might use a textbook – which is the type of book that the catalogue is promoting.

Beaux Arts (opposite)

This book was designed by Studio AS for Beaux Arts. It contains examples of work from 12 different painters and sculptors. The book features text that is set in an eye-catching fluorescent orange special colour on a greyboard cover. This is coupled with bold, fluorescent page numbers that contrast sharply with the white paper stock, and a full bleed fluorescent index is also incorporated at the back.

Client: Fourth Estate
Design: Rose Design
Colour overview: Special fluorescent green used as a highlighting device

ummy Congress:
ence, Obsession, and
the Everlasting Dead
Heather Pringle

Client: Beaux Arts
Design: Studio AS
Colour overview:
Dynamic fluorescent special
used on a greyboard base and
a white paper stock

Spot colour

A specially mixed colour such as fluorescents, metallics or any that are outside the gamut of the CMYK colour system. Colours within the CMYK colour system may also be applied as spot colours when accurate colour reproduction is essential.

Greyboard

Stock made from recovered fibres that is used for book binding, cover stock, cartons, boxes and other types of packaging. Greyboard may be laminated with other stocks.

Colour Fluorescents

Client: Section One
Design: Solar Initiative
Colour overview:
Orange fluorescent special,
controlled by white space

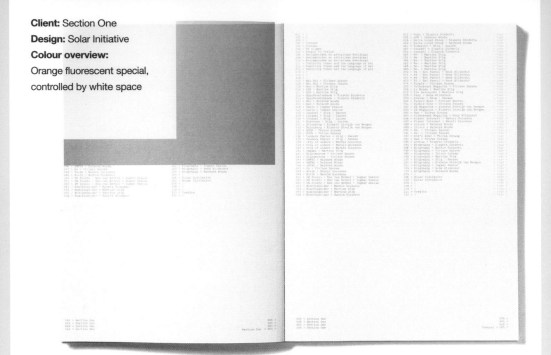

Elspeth Diederix
(Nairobi,1971)

Gerrit Rietveld Academie,
Amsterdam (1990 – 1995)
Bezalel Academy of Fine Arts,
Jeruzalem (1994)
Rijksakademie van Beeldende
Kunsten,
Amsterdam (1998 – 1999)

In het werk van Elspeth Diederix zijn alledaagse voorwerpen van hun logische vorm of functie ontdaan en opgenomen in een nieuwe werkelijkheid van een surreële orde. Allerlei materialen en personages zijn zo in het beeld geschikt dat ze hun oorspronkelijke betekenis verliezen en een nieuwe aannemen. Het illusoire beeld wordt nog sterker doordat figuranten op de foto's in een naar binnen gekeerde droomwereld lijken te verkeren en hun ogenschijnlijk onzelfsprekend handelen welbewust lijken uit te voeren.
Diederix bevon haar opleiding met schilderen en beeldhouwen, maar stapte al snel over op fotografie. De directheid van het medium stelt haar beter in staat alles te gebruiken wat ze wil. Diederix is in de eerste plaats beeldend kunstenaar, die de fotografie nodig heeft om haar creaties in een beeld te vangen met een esthetisch aansprekende vorm. Bovendien speelt ze met zaken als optische illusie, schaalontregeling, het in elkaar overlopen van kleur en vorm, transparantie en helderheid van materialen, en de morfologische gelijkenis tussen het kunstmatige voorwerp en het natuurlijke product. Al deze aspecten zouden het niet kunnen stellen zonder de specifieke eigenschappen van de fotografie. Het is de fotografie die ervoor zorgt dat vorm en inhoud elkaar versterken.
Diederix heeft in opdracht gewerkt voor ondermeer de HypoVereinsbank Frankfurt, een Amerikaanse campagne voor Voss mineraalwater en voor papiergroothandel ModoVanGelder.

Elspeth Diederix
(Nairobi, 1971)

Gerrit Rietveld Academy,
Amsterdam (1990 - 1995)
Bezalel Academy of Fine Arts,
Jerusalem (1994)
Royal Academy of Fine Art,
Amsterdam (1998 - 1999)

In her work, Elspeth Diederix strips everyday objects of their logical form or function and introduces them into a new, surreal world. Every variety of material and human character is brought into view in such a way that causes them to lose their original meaning and take on a new one. The illusory image becomes stronger because the objects depicted seem to be suspended in an introverted dream world. The figures appear to be overly aware of their seemingly unconscious actions.
Diederix began her training in painting and sculpture but soon made the switch to photography. This medium's immediacy better allows her to use anything she wants. She is, first and foremost, a visual artist who needs photography to capture her images in an esthetically pleasing form. She also uses tools such as optical illusion, incorrect perspective, the merging of color and shape, transparent or clear materials, and the morphological similarity between the artificial object and the natural product. She could never bring together all these aspects without photography, for it is this medium that enhances form and content.
Diederix has had commissions from the HypoVereinsbank Frankfurt, an American campaign for Voss mineral water, and for paper wholesaler ModoVanGelder.

Section One

These spreads are taken from a catalogue created by Solar Initiative design studio for Section One, which is based on an exhibition of work from ten up-and-coming photographers. The spreads feature a fluorescent orange special colour that is used in addition to the CMYK process colours. The use of white space to surround the orange blocks helps prevent the special colour from overpowering the design.

Process colours

The subtractive primaries: cyan, magenta, yellow and black, which are used in the four-colour printing process.

Shown below left are the four process colours. Shown below right are the four process colours overprinting a fluorescent base.

Colour Fluorescents

Metallics

A design can be embellished with decorative metallic effects in two different ways: either through the use of foil-stamping techniques, or by use of metallic printing inks. Metallic inks and foil stamps tend to be highly reflective and as such they provide a design with a striking visual element. Metallics are often used to give a more luxurious feel to a design.

The foil-stamping technique is a specialised printing process that uses sculpted metal stamps to seal a thin layer of metallic leaf on to a surface. Once heated, the foil is pressed against the substrate with sufficient pressure to ensure that the foil is fixed to the intended areas.

Metallic printing inks are used in the same manner as standard printing inks. Metallic inks are made with copper, zinc and aluminium pigments in order to produce copper, bronze, silver and gold colours that cannot be reproduced by standard process inks. Metallics are often applied as a special colour via a fifth printing plate. However, if a design is to be printed with a limited colour palette, metallic inks can be applied as the fourth plate.

Five (right)

This is a brochure created by SEA Design for UK television company Five. The minimalist cover features nothing more than the company's logotype, which is silver foil stamped into the uncoated greyboard cover. The silver foil reflects light and results in a dynamic and eye catching cover due to its ability to contrast with the stock, and also provides textural contrast.

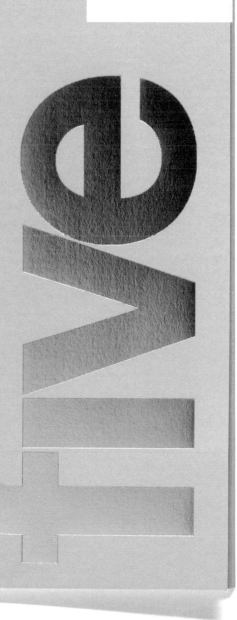

Client: Five
Design: SEA Design
Colour overview:
Reflective silver foil-stamped
logo

Client: Lesley Spencer
Design: Segura Inc.
Colour overview:
Four-colour poster print

AUTHENTIC FLAVORS
LESLEY SPENCER
AND THE LATIN CHAMBER POP ENSEMBLE
FEATURING FAREED HAQUE

www.lesleyspencer.com

Colour can be used in many different ways within a design. It can highlight specific information that might otherwise have been lost; it can draw attention; it can make the viewer feel compassion, love or hate; it can suggest femininity or masculinity and it can provide a cultural key to interpret and receive information. Colour presents the designer with limitless opportunities.

The use of colour within a design will usually require careful planning. Printed publications are usually produced in eight- or 16-page sections. If a publication does not print with four colours, any colour fall or usage will normally be restricted to certain sections in order to minimise costs. Use of an imposition plan will help a designer to determine the colour fall and placement of special colours or varnishes within a printed publication.

There are several different methods of colour detailing that a designer can use to enhance a piece of work. These range from the use of surprints, overprints, tints and special colours, to the use of different paper stocks and print-finishing techniques such as foil stamping or fore-edge printing. This section looks at the ways in which colour can be used effectively within a design.

Authentic Flavors (left)

This poster, designed by Segura Inc. for Lesley Spencer and the Latin Chamber Pop Ensemble, uses a rainbow of translucent colours that rise and form into an ice-cream cone shape, which serves as a visual metaphor to represent the flavours of the music.

Imposition

Imposition is a term that is used to describe the arrangement of pages in the sequence and position in which they will appear when printed before being cut, folded and trimmed. With the addition of colour coding, the imposition plan is used to determine the placement of the colour fall and the use of different paper stocks or varnishes.

For reasons of economy, a special colour is not usually printed in all sections of a publication unless it is instrumental to the design. The number of sections that a special colour will print is often minimised in order to keep production costs down. Planning the colour fall allows the designer to locate those pages that need to print with a special colour in order to enhance the design, and keep them in the right section.

The imposition plan also allows the designer to maximise the usage of special colours in a given section by using them on pages other than those originally intended because the colour is available for use. For example, a publication that prints in 16-page sections, and has the budget to use a special colour on one page, can use that colour on the section's remaining pages at a diminishing additional cost.

Imposition and colour planning is less critical with a job that uses the same number of colours throughout, because every page prints with the same colour(s), and as such there are no economies to be made.

Pagination
Pagination refers to the arrangement and numbering of pages in a publication.

Using an imposition plan

The diagram below illustrates how this volume has been paginated using four different paper stocks to create variation in colour reproduction and tactile qualities.

1	2	3	4	5	6	7	8	9	10	11	12	13	14	15	16
17	18	19	20	21	22	23	24	25	26	27	28	29	30	31	32
33	34	35	36	37	38	39	40	41	42	43	44	45	46	47	48
49	50	51	52	53	54	55	56	57	58	59	60	61	62	63	64
65	66	67	68	69	70	71	72	73	74	75	76	77	78	79	80
81	82	83	84	85	86	87	88	89	90	91	92	93	94	95	96
97	98	99	100	101	102	103	104	105	106	107	108	109	110	111	112
113	114	115	116	117	118	119	120	121	122	123	124	125	126	127	128
129	130	131	132	133	134	135	136	137	138	139	140	141	142	143	144
145	146	147	148	149	150	151	152	153	154	155	156	157	158	159	160
161	162	163	164	165	166	167	168	169	170	171	172	173	174	175	176

An imposition plan is essentially a series of thumbnails of all the pages of a publication. It shows how the book is laid out and allows the designer to make decisions about colour fall, paper stocks and so on.

This imposition plan shows that eight different pages (highlighted green), print with Pantone 802; notice that the use of this special colour has been kept within a single section. The fourth section (highlighted blue), prints on a gloss-paper stock, while the fifth section (highlighted orange), prints on an uncoated-paper stock. The last section prints on Kraft paper. This page has been printed on the gloss stock, which gives colours that are more vibrant than those reproduced on uncoated stock.

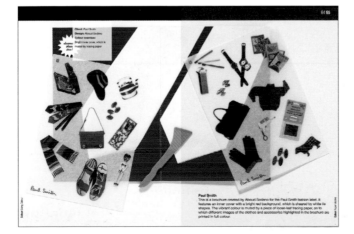

The change in paper stocks within this book means that pages 64 and 65 have very different print qualities. The colours on the gloss stock (page 64), appear brighter compared to the muted tones that are visible on the uncoated stock (page 65). It is worth remembering the effect that the selection of paper stock will have on the final product.

Colour Imposition

Client: ModoVanGelder

Design: Solar Initiative

Colour overview:

Red and green special colours incorporated in a monotone publication

▶ ongestreken papier

uit een hoeveelheid cyaan, magenta en yellow, ten dele wordt vervangen door een gelijke hoeveelheid zwart. Hierdoor wordt dezelfde kleurtint van het origineel behouden.

Aandacht besteden aan de technische eigenschappen van papiersoorten betaalt zich terug.

Het werken met ongestreken papieren biedt nog de mogelijkheid van het aantonen van echt vakmanschap. Een zeer goed druk- en bindresultaat vertegemwoordigen zowel een materiële als immateriële meerwaarde voor de ontvanger én de opdrachtgever.

▶ De kracht van eenvoud

hoofdstuk 2 zwart offset
papier papier: houtvrij romandruk
pag. 19

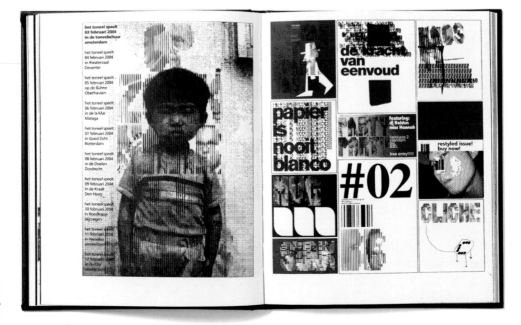

The nine sections of ModoVanGelder's publication have a number of colour treatments. Section one is printed in black on a white stock (top left); section two prints in black on a cream stock, and silver is overprinted on the black (top right); section three prints in black on a white matt-paper stock; section four prints in red and black with a series of overprints (bottom left); section five prints in two-colours with an additional varnish coating; section six prints with a series of blacks; section seven prints with a fluorescent green special colour (bottom right); section eight contains a series of silk-screen prints; and finally, section nine again prints in black on a white stock.

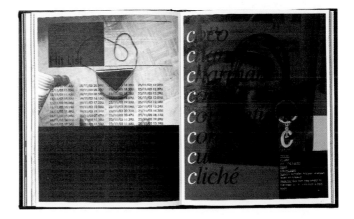

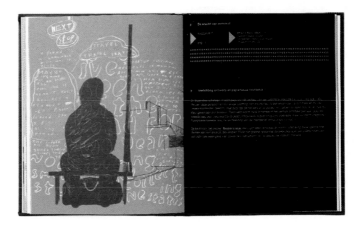

ModoVanGelder

This book was created by Solar Initiative design studio for Dutch paper company ModoVanGelder. Focusing on the power of simplicity, it looks at a variety of printing possibilities. Each of the nine eight-page sections of the book uses different paper stocks and printing techniques, but retains a two-tone colour scheme throughout: black and one other colour or lacquer. The restriction of colour usage simplifies the presentation, which allows the various treatments to take prominence.

Monotone

A single colour that is applied to an image, individual sections or an entire publication. Use of a monotone can provide an interesting visual dynamic or can create a dull, repetitive feel.

Client: Fundació Gala-Salvador Dali
Design: Bis
Colour overview:
Mixed paper stocks and random colour imposition creates an eclectic feel

The front sections of the book are printed on a silk-paper stock...

this adds vibrancy to the reproduction of four-colour imagery.

Typography retains a crisp and legible appearance.

El País de Dalí

This book uses a mixture of paper stocks, random colour imposition and different typographical treatments, to create an eclectic design. The reproduction of the content on to uncoated paper is reminiscent of a scrapbook collection, and the intervention of hand-rendered type also enhances this feel.

Later sections of the book are printed on a series of coloured paper stocks. On the grey stock (shown left), titles print in blue, and body copy prints in black. This colour sequence is reversed when printing on the cream stock (shown below).

The cream stock and greyscale image reproduction serve to standardise the display of the archived material.

Colour fall

Planning the incorporation of colour in a printed publication can be approached in a number of different ways. Most often, colour usage is managed for an entire publication (rather than for individual spreads), during its planning stage. This is achieved via an imposition and colour-fall plan that shows which pages will be printed in different colours. For example, pages 33, 36–37, 40–41, 44–45 and 48 of this book are printed with fluorescent ink, and this was detailed on our imposition plan throughout the duration of the planning stage and design process.

Colour reproduction is also influenced by paper stock. The colour of a selected stock, its ink absorbency, its surface qualities and a number of other aspects will all combine to affect the colours of the finished product.

There are a number of restrictions that will dictate the colour fall in a printed publication, and a designer must learn to accommodate these within their project's planning stage.

Photonica (right and following spread)

This catalogue for picture library Photonica was created by Browns design studio, and is based on the principles of the RGB colour system. The catalogue features red, green and blue hues of the various images, which are used to create a series of pages that flow seamlessly through the colour spectrum.

Client: Photonica
Design: Browns
Colour overview:
Content of pages changes
from red, to green to blue
throughout the book, to reflect
an RGB theme

photonica

YOU'VE JUST O[...]
BOOK. THAT'S TH[...]
ONE. FIRSTLY, A GU[...]
LIKE WHAT YOU SEE,[...]
WEBSITE AT WWW.PHO[...]
WHERE YOU WILL FIND M[...]
BY EMINENT PHOTOGRAPH[...]
TO STIMULATE YOU CULTUR[...]
AND COMMERCIALLY. SECONDL[...]
A SWATCHBOOK WITH IMAGES[...]
ARRANGED IN ORDER OF COLOUR[...]
AND SATURATION. FINALLY, A[...]
SCRAPBOOK. EACH COLOUR LEADS[...]
INTO SIXTEEN PAGES FOR YOU[...]
TO WORK IN, WRITE IN, SCRIBBLE[...]
IN AND STICK STUFF IN.

Colour fall
The pages of the publication, as depicted in the imposition plan, which will receive a special colour, varnish,
or will be printed on a different paper stock.

Colour **Colour fall**

 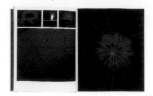

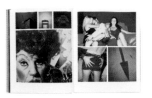 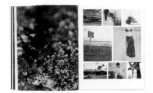 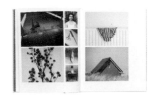

 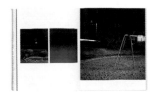

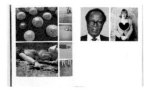 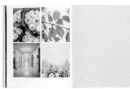 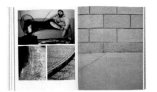

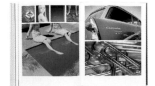

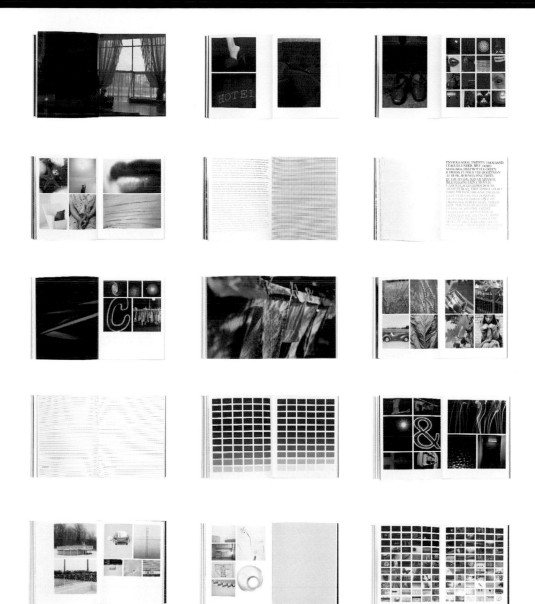

These spreads from the Photonica catalogue show how the images have been presented in red, green and blue colour bands. Colour-tint charts are used as section dividers to announce which of the colours will be presented in the next sequence. The images used either feature objects with the colour pertaining to the section they are in, or have been tinted or manipulated in accordance with the theme.

Colour Colour fall

Paper stocks

The use of different coloured paper stocks provides an often overlooked method that will add colour to a design, particularly one that would otherwise be monotone.

Paper stocks are available in numerous colours and this provides a designer with great versatility and the creative potential to combine many different types. When printed, all but the darkest colour stocks can retain text legibility.

Stock selection can have a dramatic impact on colour reproduction. Some stocks are very absorbent and as such give dull colours, whilst others have coatings that are designed to give high-quality colour reproduction. This book uses gloss-, uncoated-, and kraft-paper stocks, all of which produce different colour reproduction results. The table below outlines the suitability of different stocks for colour printing.

Stock	Characteristics	Colour reproduction	Use
Uncoated or offset	Highly absorbent, which means sharp colour images are difficult to reproduce	Good, but limited if sharp images are required	Magazines
Matt	Coated stocks that have a dull surface	Excellent, flat colour with low glare. Ideal for photorealistic images	Magazines, books, flyers, brochures, catalogues
Silk/satin/semi-gloss	More coating than matte but less than gloss stocks	Excellent, low glare, ideal for photorealistic images	Magazines, books, flyers, brochures
Gloss	Coated paper with a smooth and high-white gloss surface	Excellent, ideal for reproducing bright colour	Staple of magazine production, brochures
Cast-coated	Heavy, clay-coated stock. Pressed (or cast), while still wet against a polished, hot, metal drum to produce a high gloss finish, usually on one side of the sheet	Excellent colour reproduction	Magazines, flyers brochures
Tracing paper	Translucent stock with little space between paper fibres. Low ink absorption, difficult to print on	Possible, but limited	Special projects
Tissue paper	Thin, highly-absorbent stock	Unsuitable	Not applicable

Client: Casco Editions
Design: Experimental Jetset
Colour overview:
Colour stocks used to replicate artwork

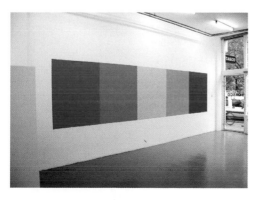

Ellsworth Kelly

This book, which was created by Experimental Jetset, is specifically designed to display an interpretation of *Blue, Green, Yellow, Orange, Red* – a piece by American minimalist artist Ellsworth Kelly. Kelly's work comprises five monochrome panels: three are the primary colours and two are their intermediary colours: green and orange. The book contains a full-scale replica of the painting, which is reproduced using different coloured paper stocks that are bound together into a single volume.

Colour Paper stocks

Client: GF Smith
Design: SEA Design
Colour overview:
Fore-edge print and
multiple colour stocks
create a graphic effect

colorplan
colour on colour

GF Smith invite
you to the launch
of colorplan

Thursday 28th
18.45pm

Za...
Fas...
89 G...
London...

Nearest T...
London...

Colorplan Brochure (above) and Invitation (left)

This is a promotional book produced by SEA Design for the launch of GF Smith's Colorplan range of paper stocks. The book contains all of the 52 coloured stocks that are available in the range. The fore edge of the book carries the Colorplan typographic logo, which is printed as a reverse out (see page 72), and as such allows the colours of the stock to show through. Use of this printing technique means that the logotype and paper stocks combine to create a rainbow effect and, when opened, the different paper stocks provide a colour spectrum effect. The front cover features a silver foil stamp (see page 71), of the same logotype.

The invitation for the launch was produced using multiple sheets of different colour stocks, which were bonded together in several harmonious colour schemes.

Fore-edge printing

Fore-edge printing is achieved using a special machine that is typically used for gilding the edges of a page. Gilding with gold or silver was originally performed to protect the pages of a book, but nowadays the technique is used to tint pages of a publication in the same colour as the cover, or for decorative effects.

Colour Paper stocks

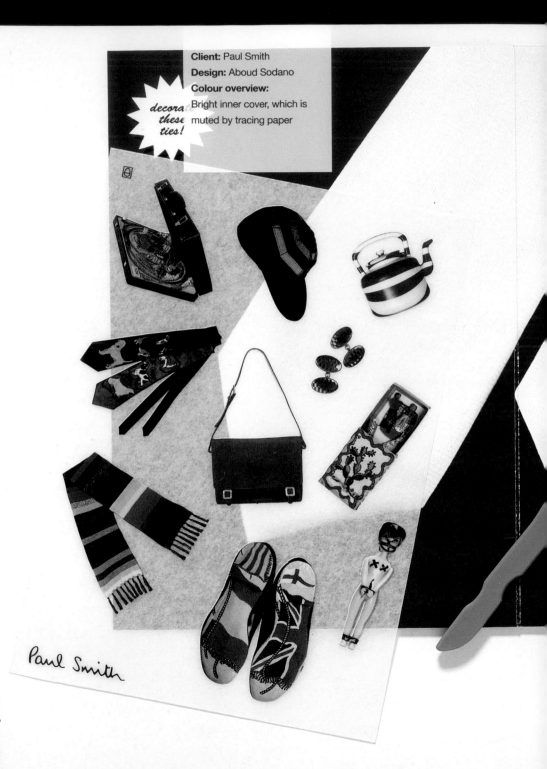

Client: Paul Smith

Design: Aboud Sodano

Colour overview:
Bright inner cover, which is muted by tracing paper

decorate these ties!

Paul Smith

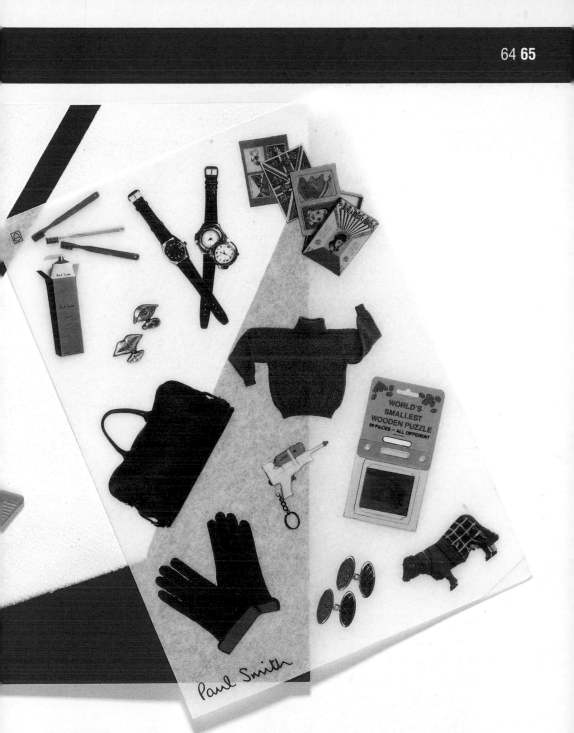

Paul Smith

Paul Smith

This is a brochure created by Aboud Sodano for the Paul Smith fashion label. It features an inner cover with a bright red background, which is sheared by white tie shapes. The vibrant colour is muted by a piece of loose-leaf tracing paper, on to which different images of the clothes and accessories highlighted in the brochure are printed in full colour.

Client: Zanders
Design: Roundel
Colour overview:
Colour stocks used as
key design element

bewegen
kombinieren
hinzufügen
ändern
focussieren
hervorheben
verstecken
enthüllen

Licht ist Farbe, eingefangen
von ZANDERS Spectral.

Mit Licht spielen, seine Farben
entdecken, von intensiv über
pastell, hin zu weiß. Licht zum
Anfassen, mit transparentem
Reflex und changierender
Wirkung. Licht das Schatten
oder neues Licht wirft.

Licht zum Bedrucken in 100
und 200 g/m², in 18 Stufen des
Farbspektrums. Mit passenden
Briefhüllen in DL, C5 und
quadratisch (160 x 160 mm).
Dieses Farbsortiment
umschließt das Licht.

ZANDERS Spectral
The colour of light

bewegen

Cherry (Rot) 200 g/m²

Zanders

This brochure was created for paper producer Zanders by Roundel design studio, and is based on the idea that 'you can'. The brochure demonstrates the different results that can be obtained by use of the coloured, semi-transparent paper stocks from the Zanders spectral range.

The verso page of this spread shows how a red stock is used specifically to obscure a red object, while the recto page demonstrates how a green stock adds animated movement to a sketch of a can of spray paint. This project illustrates that the incorporation of colour in a design is not restricted to printing, but can also form part of the stock selection decision too.

This brochure was distributed to a number of European clients, hence the printing of multiple editions in a variety of languages. Each edition was printed with a different black plate that contained language-specific elements. This process is called colour banking.

hervorheben

Mint [Hellgrün] 200 g/m²

hervorheben

Mint [Hellgrün] 200 g/m²

Colour Paper stocks

Colour detailing

Colour can provide effective enhancement to a design because it grabs the attention of the viewer. Colour detail can also be included in the format or technical specifications of a publication.

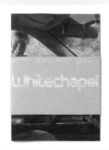
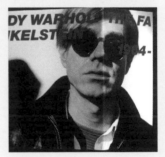
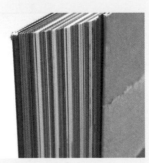

Head and tail bands
Head and tail bands are decorative, and often coloured, cloth tapes that protect the top and bottom of the spine.

Fore-edge printing
Historically, gold or silver was printed on page edges to protect important works. Nowadays a range of decorative colour can be printed on a page edge.

Flaps
These are an extension of the cover, which often make a book feel more substantial. Flaps offer an opportunity for a multitude of colour detailing.

Endpapers
Coloured or printed stock is often used for the outer pastedown and flyleaves, which comprise the endpapers printed at the front and back of a publication.

Stocks
Sections printed on different paper stocks will colour the fore edge of a publication. Different stocks can provide a visual index that allows the reader to easily access different sections.

Bellybands
A bellyband is a separate loop, or strip of paper, or plastic substrate, which wraps around the 'belly' of a publication. These can be coloured to draw attention to key information.

Clockwise from top left: details from designs by Spin, featured in Basics Design: Format; Studio Myerscough, featured opposite; Pentagram, featured in Basics Design: Typography; Society, featured in Basics Design: Format; Rose Design, featured in Basics Design: Format; Spin, featured in Basics Design: Typography.

MAK ARCHITECTS

Client: Black Dog Publishing
Design: Studio Myerscough
Colour overview:
Fore-edge printing that
homogenises with the colour
of the cover

MAK Architects

This book, created by Studio Myerscough for Black Dog Publishing, features fore-edge printing on the cut edges of the perfect-bound pages, which homogenises with the colour of the cover. Coupled with the use of minimal typography, this transforms the book into a solid object.

Client: Syn records
Design: North
Colour overview:
Different coloured foil-stamped
line art, set against a pastel
background

norico
Lovely Worl

Estatuto de Autonomía de Canarias

Client: Parlamento y Gobierno
de Canarias
Design: Wladimir Marnich
Colour overview:
Vibrant orange used to provide
navigation and identity

Statutory Declaration of the Canary Islands (above)

Pictured above is a limited edition publication, which was created by Wladimir
Marnich to celebrate the twentieth anniversary of the Statute of Autonomy of the
Canary Islands. Orange is used to provide colour detailing on the breaker pages,
headers, binding and to colour the inside of the French-fold pages. The use of colour
also helps the reader to navigate through the publication and provides an identity.

Lovely World (left)

This artwork was produced by North design studio for the 'Lovely World' single by
Japanese singer Norico, who is represented by Syn Records. The butterfly images
that represent this particular lovely world are rendered using different coloured foil-
stamped augmented line artwork, which is set against a lavender background.

Foil stamp

A metallic foil or coloured tape that is pressed on to a substrate using heat and pressure.

Colour Colour detailing

Colour layers

There are three techniques that can be employed to combine or layer printed fore- and background elements, such as type and an image. These are surprint, reverse out and overprint. These techniques may be used to optimise visual appearance and clarity where elements overlap, or to produce interesting graphic effects.

Surprint
A surprint is defined as two elements which print on top of each other, and that are tints of the same colour.

Reverse out
A reverse out removes parts of a flood colour, which leaves white space in the shape of a given design, letters or characters.

Overprint
An overprint describes two elements that are printed one on top of the other; usually a darker colour is printed over a lighter colour.

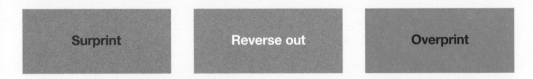

Metis – Urban Cartographies (right)
This book was produced for Black Dog Publishing by Gavin Ambrose, and features a combination of surprint and reverse out typography on the breaker pages for each chapter. Notice that the surprint is a lighter tint of the solid colour, while the reverse out is marked by an absence of colour.

The titles of the five chapters appear on the breaker pages so that the reader knows where they are within the book, in this way the use of surprints and reversal outs further enhances navigation.

Client: Black Dog Publishing
Design: Gavin Ambrose
Colour overview:
Surprint and reverse out used
on each of the breaker pages

and Longitude Resolved

Britannia Basin – Manchester

Mimetic Urbanism – Verona

Micro Urbanism – Ottawa

Cabinet of the City – Rome

met
urba
car
Mic

micro urbanism

Colour Colour layers

Tints

The reproduction of colour is achieved by screening the three trichromatic process colours: cyan, magenta and yellow – usually in increments of 10%. There are 1,330 available tints from these three process colours, and many more (nearly 15,000), are obtainable by incorporating black as well.

The two sets of colour bars show 10% increments of each of the three process colours. Generally, tints of stronger colours are more distinguishable, even at lower concentrations, than tints of lighter colours. This distinction will be affected by the surrounding colours of the design as well as the colour of the stock it is to be printed upon. Notice how the yellow bar disappears into the colour of the page at high concentrations, and yet is visible at lower concentrations.

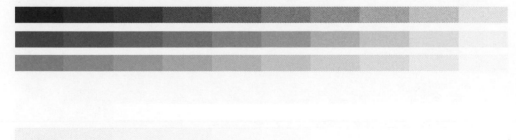

A Contemporary Cabinet of Curiosities: Selections from the Vicki and Kent Logan Collection (right)

A Contemporary Cabinet of Curiosities: Selections from the Vicki and Kent Logan Collection is a book produced for the Californian College of Arts and Crafts by Aufuldish + Warinner design studio. Images of works by different artists in the collection are reproduced in a single, warm-grey tint that produces a faint, ghostly representation of the original image. The same colour treatment on all the images unifies the works as a single collection.

Client: The CCAC Institute
Design: Aufuldish + Warinner
Colour overview:
A single tint used throughout to unify works from the collection, and creates a ghostly effect

KATHARINA FRITSCH Totenkopf (Skull)
1997/98

DAMIEN HIRST Philip (The Twelve Disciples)
1994

Overprinting

An overprint is a specific technique that is applied by printing one element of a design over another. This creates multiple layers of information and adds texture to a design. The overprinting of different inks will create different colours; often, in order to preserve the dimensions of a design, ink trapping or knocking out will be required.

The above illustrations demonstrate the different results achieved through overprinting and knocking out. On the left, knocking out retains the purity of the printed colours. On the right, overprinting effectively blends the printed colours to produce new ones. No green was printed, but the overprinting of cyan on yellow produces this. Likewise, a red is produced where magenta overprints the yellow.

Ink trapping refers to the overlapping of areas of coloured components to account for any misregistration on the printing press. This process is required because the halftone dots that form printed images are of different sizes and are arranged at different screen angles. If the coloured elements are overlapped it will prevent the appearance of white gaps at the point where they are supposed to meet.

A knockout is a gap which is left in the bottom ink layer so that an image printed over it (that overlaps it), appears without colour modification from the other ink. The bottom colour is literally 'knocked-out' of the area where the other colour overlaps.

These four squares demonstrate how the traditional four-colour printing inks – cyan (C), magenta (M), yellow (Y) and black (K) – behave when reproduced separately.

Here, the four colours are printed in sequence from cyan to black, but they 'overprint' one another.

When the individual blocks are printed as solid colour, as they are here, the results are very rich and without halftone dots. Here magenta overprints cyan to create a rich, royal blue.

Overprinting yellow on magenta and cyan results in a rich black, which is far darker than a black printed on its own.

The darkest black, a four-colour black, occurs when all four colours are overprinted over each other.

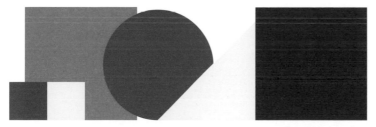

All colours are set to default so that they knock out or fail to print at those points where the shapes intersect.

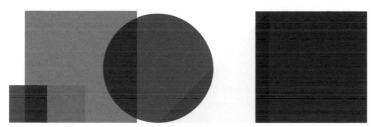

All colours are set to overprint in the CMYK sequence, and this results in additional colours being formed at those points where the shapes overlap.

Colour Overprinting

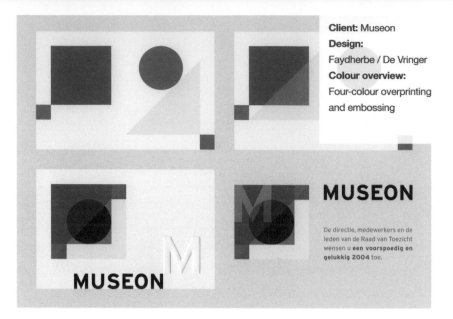

Client: Museon
Design:
Faydherbe / De Vringer
Colour overview:
Four-colour overprinting
and embossing

MUSEON

De directie, medewerkers en de
leden van de Raad van Toezicht
wensen u **een voorspoedig en
gelukkig 2004** toe.

2004 is voor het Museon een heel bijzonder jaar. We vieren namelijk het hon-
derdjarig bestaan van het museum. In die 100 jaar zijn we ons ideaal trouw
gebleven om op een educatieve en verrassende manier jong en oud de rijk-
dom en verscheidenheid van het leven op aarde te laten zien. Met prachtige
tentoonstellingen, pakkende educatieve programma's en bijzondere activi-
teiten weten we jaarlijks een groot publiek aan te spreken.

In het komende jaar zal het Museon een aantal vernieuwingen realiseren. Zo
wordt in oktober de nieuwe permanente tentoonstelling op de eerste ver-
dieping van het museum gepresenteerd. Deze expositie krijgt de titel Jouw
Wereld, mijn Wereld mee en geeft, met behulp van de meest actuele pre-
sentatiemogelijkheden, inzicht in het menselijk leven op aarde, zowel vanuit
een natuurlijk als cultureel perspectief.

Het wordt een feestjaar met een speciale jubileumtentoonstelling: Museon,
100 jaar, 100 gezichten, 100 keuzes uit de collectie. Honderd bekende
en minder bekende Nederlanders hebben een keuze gemaakt uit de collectie
van het Museon. Deze presentatie geeft een verrassend overzicht van het
werk en de relaties van het Museon. Verder zal het Museon een tentoonstel-
ling produceren die ook door Europa gaat reizen. ©opyright Nature toont
hoe mooi en vindingrijk de natuur is en hoe de natuur als inspiratiebron kan
dienen bij het zoeken naar duurzame oplossingen in de moderne samenle-
ving.

Het zal voor het Museon een actief en vooral inspirerend jaar worden. We ho-
pen u tijdens dit jubileumjaar in het museum te mogen begroeten.

Bert Molsbergen

Museon

This identity system was created by Dutch design studio Faydherbe / De Vringer for
Museon. It is formed from four basic shapes and the three primary colours, which
have been applied with overprinting techniques and enhanced by an embossed
initial. The structural and modernist approach results in a memorable and playful
identity, and the addition of an embossed initial create a non-static logo. The design
is revisited on page 148 to show how it has been further developed through an
extended use of colour.

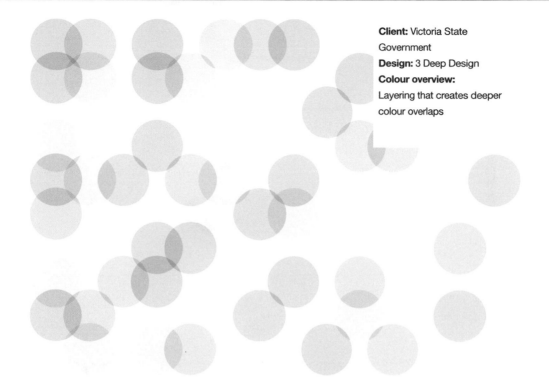

Client: Victoria State
Government
Design: 3 Deep Design
Colour overview:
Layering that creates deeper
colour overlaps

The State of Design

This project was produced by 3 Deep Design for the Victoria State Government in
Australia. The combination of coloured typography and the marque of interlocking
coloured circles was created to satisfy a range of different design specifications,
determined by printed media and electronic media requirements. The coloured circles
in the marque (bottom) and design (top) use a layering effect that combines the pale
colours of the individual circles to create deeper colours where they overlap.

Colour Overprinting

Client: CBK Dordrecht
Design: Solar Initiative
Colour overview:
Knockouts and overprints
of coloured inks to provide
visual effects

Proeftuin

This catalogue was created by Solar Initiative for Dutch art centre CBK Dordrecht. The catalogue features various knockouts and overprints, which have been used to achieve specific visual effects. The spread featured at the top of this page has a yellow knockout; the following spread also has a yellow knockout, but gives the impression that it has been overprinted; while the bottom spread (also enlarged and shown on the facing page), has a cyan and magenta overprint on its verso page. The catalogue also features a cyan and yellow overprint on the gutter.

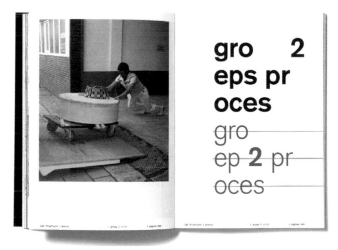

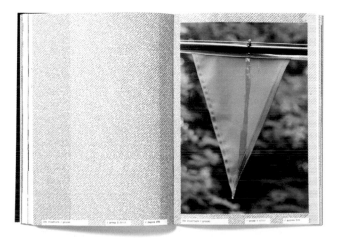

Client: North
Design: North
Colour overview:
Foil stamp used to standardise
colour detail and unify a
disparate set of logos

So far we have looked at how colours can be selected, classified and reproduced. Colour, however, is not only used for the cultural or symbolic values that it imparts, but is frequently used to embellish different components, homogenise a disparate set of images, or to add a hierarchy to the different textual elements used in a design. An understanding of some of the basic colouring techniques – such as toning, contrast, gradients, manipulation and hierarchy – allows a designer to add an intelligent structure and cohesion to a design that it might otherwise be lacking.

This section will look at some of the many ways that images and text can be coloured to produce more striking, meaningful and consistent results. The ability to manipulate design elements through the use of colour allows the designer to better communicate their intended meaning.

North Mailer (left)

This is a promotional mailer by and for North design studio. It features a foil-stamp design and incorporates a selection of different logos that North have previously created for their many clients. The individual logos were originally designed with different colours to those seen in the mailer, but for this project they have been unified and standardised by the foil stamp and colour detail so that no single logo is elevated from the rest.

Colouring images

A designer can colour an image through use of duotones, filters or a number of other techniques. Colouring an image can impart an element of drama to a design or suggest a certain style, perhaps radically changing it, either by accentuating or diminishing specific details, as shown in the example here.

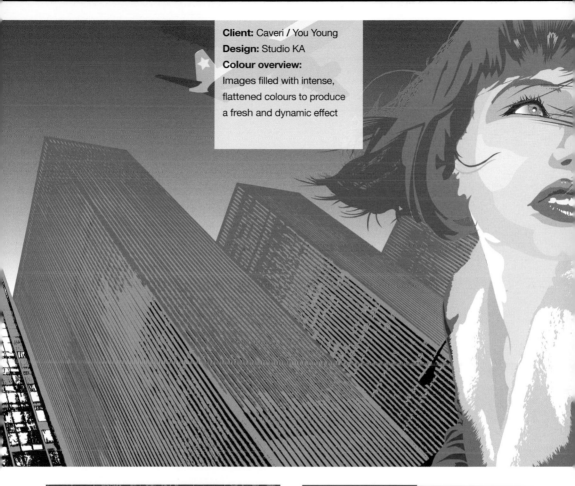

Client: Caveri / You Young
Design: Studio KA
Colour overview:
Images filled with intense,
flattened colours to produce
a fresh and dynamic effect

You Young (above and left)

This brochure was produced by Studio KA design studio for Italian fashion designer
Enrico Coveri's You Young brand. A mixture of photographs, mediated images, line-
art illustrations and areas of flattened colour create hyperrealistic street scenes, which
are almost comic book in their nature. The images are printed on a high-gloss stock
in order to maintain the intensity of the colours, and highlights, such as the girl's hair,
are picked out in fluorescent orange. The overall effect is fresh and dynamic,
specifically created to appeal to young women.

Colour Colouring images

Tonal images

A tonal image is akin to a black-and-white photograph in which the white tones have been replaced by another colour or colours. Usually the replacement will be one of the process colours, but any colour can be used. A duotone is a tonal image that is produced using two colours.

The use of tones creates visual uniformity between images, as all coloured detail is reduced to tones of a single colour that is universally applied. This simplifies a print job because the number of colours that need to be printed are reduced.

From left: the original black-and-white image; a black and cyan duotone in equal amounts provides a balanced image; a black and magenta duotone; a duotone flooded with solid cyan to create a more graphic image; a black and magenta duotone in equal amounts; and a flooded magenta duotone.

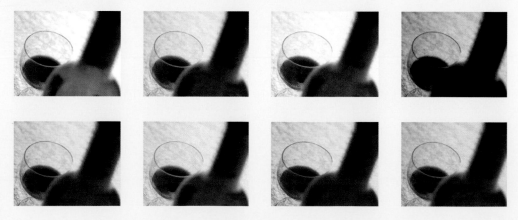

Shown top left is the original image, to its right is a sepia-tone version. This is followed by lighter and darker versions of the sepia image, these have been created by adjusting the brightness values. The final four versions of the image (shown on the bottom row), have been coloured with maroon, green, purple and yellow.

Client: The California College of the Arts
Design: Aufuldish + Warinner
Colour overview:
Duotone images add colour depth and reduce costs

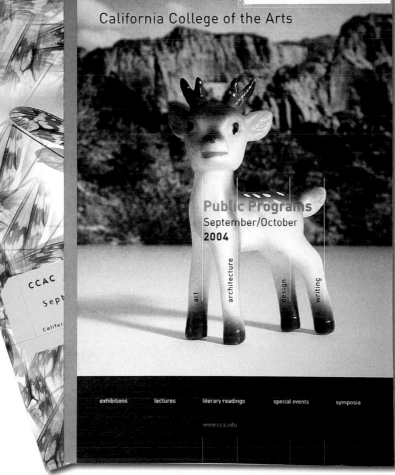

California College of the Arts

This series of leaflets was produced by Aufuldish + Warinner for the California College of the Arts. The leaflets are printed in two colours and incorporate duotone images. The duotone treatment provides more colour depth to the leaflets and reduces the production costs by limiting the range of colours used.

Colour Tonal images

Colour manipulation

Using a limited palette of controls, it is possible to alter the appearance of an image; from subtle colour adjustments, to more startling graphic interventions.

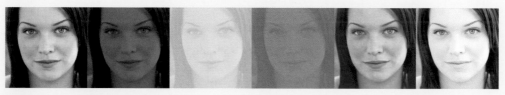

Levels

Levels refer to the distribution of tones within the image area. They can be adjusted precisely to select where the darkest and lightest points within an image will be. Levels allow us to control the 'black point', the 'white point' and the mid-grey setting.

Left to right: the original image; a reduced colour output; a bleached-out effect; a combination of both, which results in a grey tone; an increased RGB channel; and a removal of magenta.

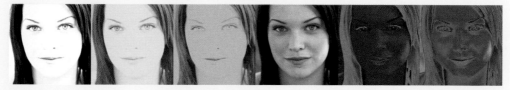

Curves

Curves map the brightness values of an image, as such they allow a designer to make a pixel brighter or darker. Curve adjustments can be used to improve the contrast of an image or to make a creative intervention that borders upon abstraction.

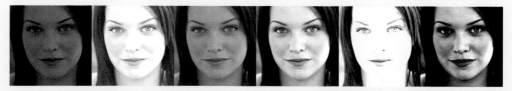

Brightness and contrast

The brightness and contrast control allows a designer to manage how light or dark an image is. Adjusting these values can add shade or highlights to an image.

Left to right: a darker brightness value; a lighter brightness value; less contrast; more contrast; more brightness and contrast; less brightness and contrast.

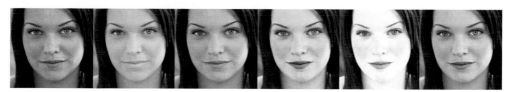

Hue and saturation

These values allow a designer to change the colour of the whole image or a highlighted part of it. Hue selection alters the actual colour, while saturation adjusts the depth of colour. The first two images shown here demonstrate hue changes, the second pair show saturation changes, the fifth image shows a blanket colour manipulation, and in the final image, only the woman's eyes and lips have been manipulated.

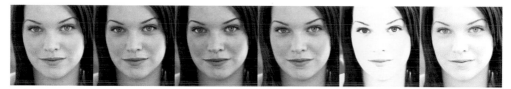

Colour balance

Colour balance can be used to make adjustments across a wide range of colour variations. For example, the first four images (shown left to right), demonstrate how to make warmer or cooler toned versions of an original image. The final two images show how more dramatic alterations can create an abstraction.

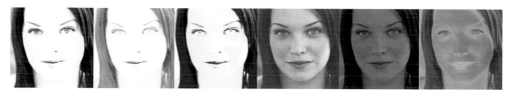

Channels

A channel is an individual colour that makes up an image. Many images use the same combinations of channels (such as RGB, RGB + transparent, CMYK or greyscale), but there is no need to be restricted to these. The first image here has a basic adjustment to the colour intensity; separate channels have been manipulated in the next pair of images; the fourth image has some black removal; the fifth image is a deep red mixture; and the final image a duotone effect.

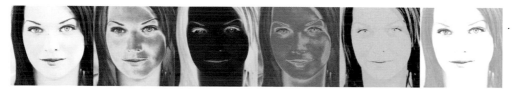

Experimentation

Most techniques applied to the images on this spread are used as part of an overall image production process and not in isolation. Experimenting with combinations of different techniques produces more creative results.

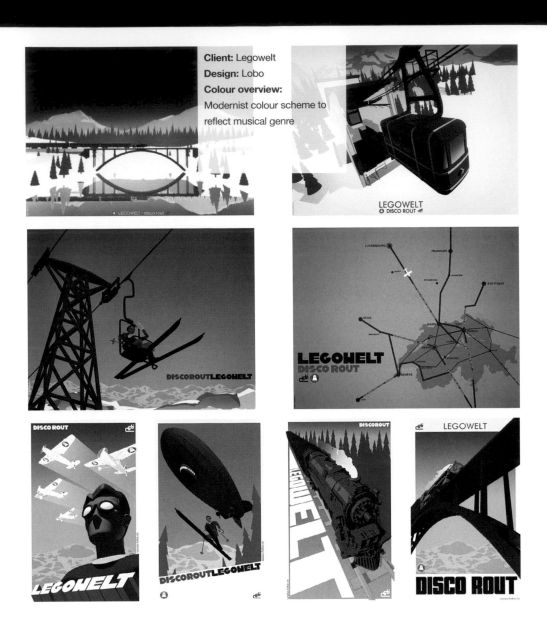

Client: Legowelt
Design: Lobo
Colour overview:
Modernist colour scheme to reflect musical genre

Legowelt

These images were created by Brazilian design agency Lobo, for German techno band Legowelt. The images are pastiches of posters from the early twentieth century, which have been modernised with colour schemes of vivid reds and blues.

The posters celebrate what was, at the time, considered the cutting edge of industrial-age technology: trains, airships, aeroplanes and steel bridges. Techno is a modern music genre and so the association is that the music of Legowelt is progressive, optimistic and promises a brighter and better future.

Colour Techniques

wide world

Client: Kelaty

Design: Still Waters Run Deep

Colour overview:

Level values in blue and red channels increased to add depth

Channels

Adjustable colour information relating to one of the colours of a colour system. For example, an RGB image has three channels while a CMYK image has four. Channels can be altered, or printed out of sequence, to create various effects:

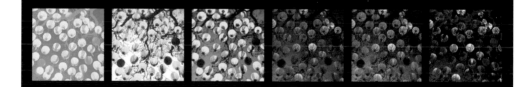

Kelaty

This publication was created by Still Waters Run Deep design studio for rug supplier Kelaty. In the image shown on the recto page of the spread, the levels in the blue and red channels have been increased to enhance the intensity against the colour of the sky and of the orange objects.

Colour Colour manipulation

Gradients

This is a type of image fill that allows specific colours to be applied to a bitmap image, which creates a transitional effect that flows from one colour to another.

This effect can be used to provide a uniform treatment to various photographic elements by reducing them to coloured silhouettes or outlines. The application of a gradient can produce a number of creative possibilities, for example, replacing all colours with silvery-grey values will create a 'chromed' image.

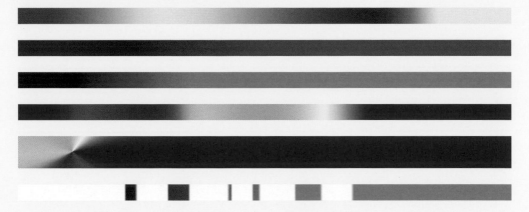

The bars above demonstrate the results of a variety of gradient fills. From top to bottom these are: a colour-white fill that gives a metallic effect; a gradient which moves from one colour to another; a gradient that uses a variety of colours; a gradient that uses the full colour spectrum; a full-colour spectrum gradient from a central point to give a fanning effect; and a gradient abstraction.

As well as enhancing bitmap files, gradients can equally be applied as a text infill (shown left), or applied as a simple overlay to an image (shown right).

Client: Issey Miyake
Design: Research Studios
Colour overview:
Text with selective gradient
colour fill

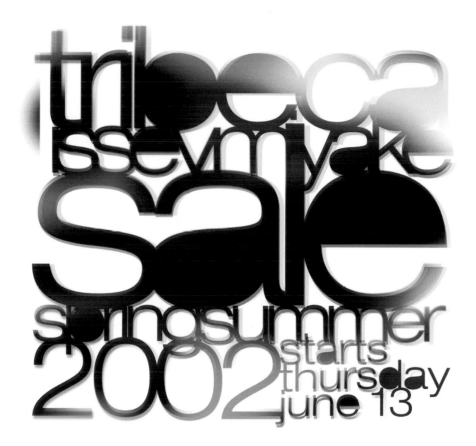

Issey Miyake

This poster, created for fashion designer Issey Miyake by Research Studios, features a gradient colour scheme and positions colour fills in the place of the character's counters. The selective way in which the colour has been applied to the different parts of the design results in a shimmering, summery effect and this is in keeping with the poster's promotional purpose.

Colour Gradients

Undercolour addition

The black produced by the black printing plate can look pale and washed out. To overcome this, large areas of black often have a 50–60% cyan bouncer, which will improve its appearance and colour depth.

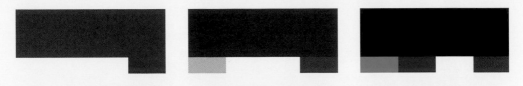

Left to right: the first panel is printed black, the middle panel is printed with a 60% cyan bouncer, and the final panel is a full-process black. Use of the other process colours provides a deeper and richer black.

These three portraits are printed in the same way as the panels shown above. Notice how the cyan bouncer creates a duotone, while the CMYK black has greater tonal definition and fuller shadow areas.

Using a four-colour image as an undercolour addition can produce an interesting effect. This portrait (above), is overprinted with an 80% black and and then a 100% black. Notice how the image of the woman remains visible.

PAGES
82–97

Client: Citigroup
Design: Spin
Colour overview:
Process colour details in
process black block

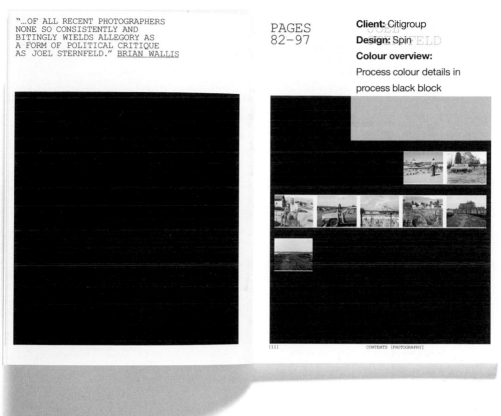

Citigroup Photography Prize 2004

This publication was created by Spin design studio for Citigroup. It incorporates undercolour addition as a creative design element by applying the process black across the pages. Some of the images on the pages are printed in four colour, whilst others are not. The weakness of the process black allows the viewer to pick out some details from the images that have not been reproduced as four colour. These details appear as a stronger black.

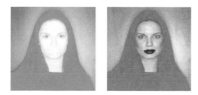

This technique creates the illusion of a screened overprint, but in reality the black blocks can be applied as an extension of the existing black printing plate.

Colour Undercolour addition

Hierarchy

A hierarchy is a logical, organised and visual guide, which is used for the text headings that normally accompany body text. Hierarchy, in this context, indicates different types of content through variations in point sizes and styles.

Colour can be used to establish a hierarchy.

A piece of text, when set as a solid block, can be hard to navigate.

Colour can be a useful tool to demarcate different levels of content importance or hierarchy. Typography typically uses titles and subheads to establish order. The examples shown here demonstrate that more experimental hierarchies can be employed.

Weights and shades.
Using different type weights and shades.
Here a series of type weights have been introduced. A heavy weight is used for titles, a light weight for subheads, and a book weight for body text. This intervention allows for **important information** to be highlighted, creating a sense of spatial relationships.

More dramatic interventions can be made using colour blocks to underpin the text.
Text can overprint colour (as above), or be reversed out (shown here).
A surprint can also be employed, using a different shade of the same colour.

_A colour underscore is used in conjunction with an indented paragraph to indicate the starting point.
Highlighting the first word in a piece of text is another device to denote the beginning.

In this example magenta is used to underline and denote the heading.
Cyan is used to underline the subhead or standfirst.
The main body text is set in black. Colour has been employed effectively to arrange levels of importance, or hierarchy.

A pull quote is an extract of the body text, which is inserted elsewhere in the copy.
It is often used to reinforce an important piece of information.
A quote is a reference to another piece of work or statement made by a person.

The white blocks are used here to replace punctuation, in this case speech marks ("")

Client: MGEITF
Design: Form Design
Colour overview:
Vag Rounded typeface infilled
with graduating colour

Media Guardian Edinburgh International Television Festival

This identity for the Media Guardian Edinburgh International Television Festival was
created by Form Design. The colour hierarchy here is used to clearly distinguish each
word and helps make sense of the rather complex name, which is normally written as
an acronym. The rounded Volkswagen (or Vag Rounded), typeface is used in different
point sizes, and each character is infilled with graduating rainbow colour. The implicit
message of the design is that the festival covers the whole spectrum of television.

Vag Rounded was developed for automobile producer Volkswagen in 1979, and is a
variation on the Grotesque sans-serif designs from the nineteenth century.

Colour Hierarchy

Client: Project²

Design: Spin

Colour overview:

Dynamic textual hierarchy

Inleiding

Die site van het Droogdokkeneiland is schitterend, met haar prachtige zichten en unieke industriële architectuur. Deze plek is bovendien het geheugen van de haven. Anderzijds vormt het vandaag een verlaten eiland op het Eilandje. Het is een post-industrieel stadsdeel zonder band met de stad.

Ons team is er van overtuigd dat het Droogdokkeneiland een trekpleister kan worden voor heel Antwerpen. Dit weegt aan globale, kwalitatieve urbanistische visie voor het hele gebied. Monteviderewijk incluis. Om van dit gebied een bruisende stadswijk te maken, nieuw verbonden met de stad, dient er gewaakt te worden over het evenwicht tussen de verschillende functies en invullingen. Zo voorzien wij 70% appartementen in alle prijsklassen, sociale woningbouw en bejaardentehuizen, 15% recreatie, cultuur en congrescentrum en 15% kantoren.

Project² wil de stad een Droogdokkenpark schenken dat de groene long kan worden van het Noord'. Op de mooiste plekken van dit park voorzien wij architecturale iconen met culturele invullingen, ontworpen door waarschijnlijk het belangrijkste architectenkantoor ter wereld, Herzog & de Meuron, onder andere bekend voor het Tate Modern museum in Londen.

Gezien de uitzonderlijke kwaliteiten van de site en de uitdaging die deze ontwikkeling betekent, hebben wij een team van verschillend bijeengebracht aan met alle belanghebbenden een visie te vertalen in een concreet plan. Wij werken ook samen met sterke Vlaamse en internationale institutionele partners, waardoor deze plannen ook effectief gerealiseerd kunnen worden.

Het is één grote ontwikkeling die een integrale aanpak vraagt

Deze plek is het geheugen van de Antwerpse haven. De architecturale schoonheid van de droogdokken herinnert aan de ontfhocters uit de oudheid.

Niet enkel de droogdokken zelf zijn mooi. De hele site ontplooit zich als een eiland omringd door water. In het noorden is de grens van het Droogdokkeneiland meteen ook de grens tussen oude en nieuwe haven, en dus tussen stad en haven.

Deze plek wordt ook gekenmerkt door haar get616 aan stedelijke structuur, haar campuskledt en haar school.

Vandaag heeft het Droogdokkeneiland geen band met de stad. Het is een post-industrieel gebied en zijt er verblert bij. Het nieuwe, herontwikkelde Droogdokkeneiland mag geen stapschot of een levenloos businesspark worden. Het moet integendeel een bruisende en boeiende stadsdeel worden, dat een door aan haar verleden en dat eindfleus naar de toekomst kijkt. Daarom moet er een evenwicht worden gevonden tussen residentiële, culturele en recreatieve functies en kantoren. Deze buurt heeft zonder twijfel het formidabele potentieel om een trekpleister te worden voor de hele stad.

Om dit potentieel tot uiting te brengen moet men ten eerste voor ogen houden dat het Droogdokkeneiland en de Monteviderewijk nauw met elkaar verweven zijn. Het is een buurt, fusen deze buurt en het Eilandje in haar geheel, en de stad mag er geen breuklijn bestaan.

Ten tweede zijn de energie aanpak, langetermijnvisie en engagement op het gebied van kwaliteit even noodzakelijk om deze buurt een boeiende aantrekkingskracht te maken. Daarom hebben wij con Roger Diener, een van de beste architecten en urbanisten in Europa, gevraagd een ontwerp te maken voor deze site. Rekening houdend met het Masterplan van Buro 5 en met het beeldkwaliteitplan. Roger Diener heeft onder meer in Zweden in opdracht van de universiteit van Malmö, de oude havensite naadloos aan de overkant van de Oude Stad hertekend.

Het congrescentrum wordt een icoon dankzij een evenwichtige functionele mix

Het objectief van ons plan is een levendige buurt te creëren. Het voorziet voor onze plaag voor al dus een vrij hoge dendsiet van bebouwing en een evenwichtige mix van functies aan de rand van het water en van het park dat wij willen aanleggen. Ongeveer 70% van het aanbod wordt gereserveerd voor appartementen in alle prijsklassen, sociale woningbouw en bejaardentehuizen, 15% voor kantoren en 15% voor culturele functies, het congrescentrum en hotels, winkels, cafés en restaurants. In het epicentrum van dit gebied, waar activiteit en visuele intensiteit elkaar ontmoeten, moet het congrescentrum worden ingeplant. Enkel dan kan het congrescentrum een architectuurale en maatschappelijke icoon worden, een landmark.

Een veel voorkomend probleem van congrescentra is dat de gebouwen leeg en verlaten zijn op dagen dat er geen congres plaatsvindt. Bovendien zijn dergelijke – dure – gebouwen moeilijk te rendabiliseren en vormen ze dus een financiële last voor de instantie die erover instaat. Om deze problemen te verhelpen hebben wij het congrescentrum gecombineerd met verschillende complementaire functies, zoals een hotel, restaurants en cafés. Hierdoor is het gebouw energiek continu in gebruik en gemixt net zodanig van schaalvoorzieten en synergieën waardoor het ook merkelijk goedkoper wordt. Wij hebben het congrescentrum samen met de andere functies ondergebracht in een torengebouw en vormen ze dus een belevike en architecturale baken moet worden. Het Rockefeller Centre in New York is een goed voorbeeld van deze strategie. Men kan zich zelfs inbeelden dat hoger in de toren er eveneens appartementen of kantoren worden aangeboden. Op de manier wordt de congresfoen een gebouw dat het hele jaar door leeft. Met de vaarten bijna teleftijk in het water zal de congrestoren daarenboven al eenvoudig zich ver leefte de versnaten slotoren momenteel op deze plaats vervult, het zo ni. Het zal orgelijpt van het Kattekijkade zijn.

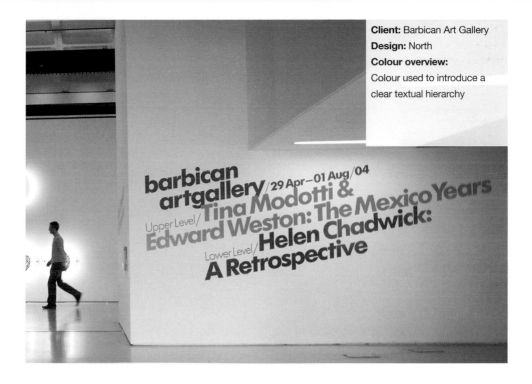

Client: Barbican Art Gallery
Design: North
Colour overview:
Colour used to introduce a
clear textual hierarchy

Barbican Art Gallery (above)

This signage for the Barbican Art Gallery in London, by North design studio, was
applied directly to the wall. The type is set with tight kerning and leading, and colour
is used to separate the three text sections. The orange colour, used for the middle
section, is lighter than the colour of the copy that precedes and follows it, which
prevents any sensation of claustrophobia within the tightly set block.

Project[2] (left)

These spreads are taken from a two-part book, which was produced by Spin design
studio for residential and commercial property developers Project[2]. In this particular
text hierarchy, colour is used for the titles to inject dynamism in the design's simple
format, which is dominated by the blocks of body text.

Colour Hierarchy

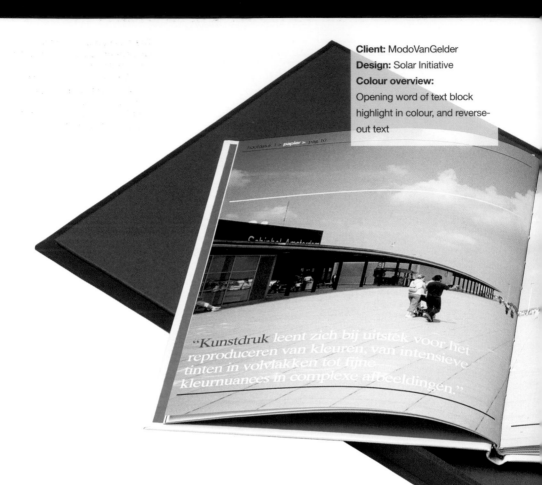

Client: ModoVanGelder

Design: Solar Initiative

Colour overview:

Opening word of text block highlight in colour, and reverse-out text

De Kracht van Kleur (The Power of Colour)

This book, created by Dutch design studio Solar Initiative for ModoVanGelder, uses colour to highlight the first word of the paragraph. In this design the text has been reversed out in white from a very light background, providing a low contrast that makes the copy difficult to see. The use of a colour to highlight the first word enables the reader to easily locate the start of the text block.

The addition of a simple element of colour can transform a bland design into an engaging one. The use of colour creates a hierarchy within the text, a focal point for navigation, and a counterbalance to the serenity of the underlying images.

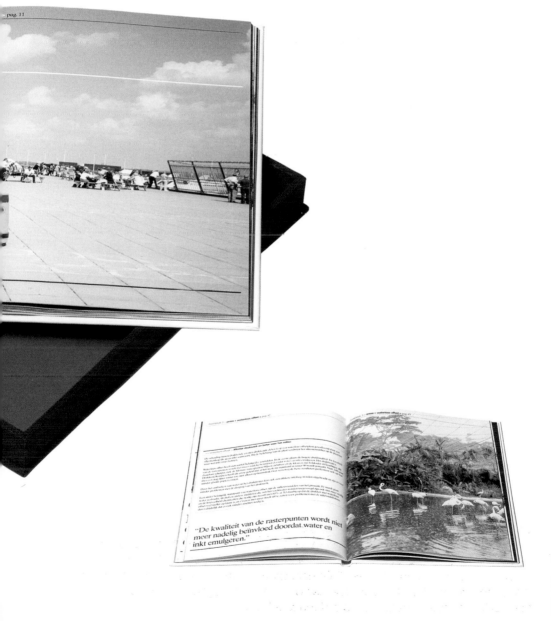

_The growing importance of museums – first as repositories for the traces of an idealised Antique past, then as showcases for the fruits of the industrial present – went hand in hand with the dramatic alteration of the economic and social landscape. New industries fuelled a new kind of cultural production. The leading industrialists, eager for acceptance, collected extensively – at first the Old Masters, then increasingly the work of their contemporaries. Many founded museums with their private collections – Carnegie, JP Morgan, Frick, Mellon, Getty, Thyssen-Bornemisza – the list is a long one. At the same time, tax-supported museums slowly began to become cultural players in their own right, and started buying and collecting aggressively. The Museum of Modern Art, the LACMA and the Metropolitan are only a few examples of publicly supported museums that began to change the face of cultural production. Soon it was not just collectors and galleries, but curators, who were making and breaking artists' reputations.

_This was especially true of modern art, which deliberately challenged many of the conventions – still rooted in the Renaissance aesthetic of pleasure – about what art was or should be. The emphasis on art began to shift away from [...] in which meaning [...] was paramount. From [...] Jackson Pollock [...] Beuys to Art and [...] Actionism, Marina [...] – much of cont[...] upon this concept of making meaning

_The change was not without its consequences. A [...] so much emphasis [...] 'meaning' that v[...] increasingly ind[...] evangelists. Works from the wilderness mini prophets to announce they coming, and the 20th century was not short of those. The Gimpel brothers, Alfred Barr, Peggy Guggenheim, Nicolas Serota, Jean Christoph Amman all championed a modern art of meaning-making. This was also the case when it came to writing about art – of all periods. As James Elkins discovered, Leonardo's *Last Supper* was allotted a mere two pages by Vasari, yet Leo Steinberg's more contemporary account, at 113 pages, is over sixty times longer. Meanwhile Giogione's *Tempesta*, which attracted only two sentences in the 16th century has subsequently become the principal subject of at least three books and some 150 essays.

Client: **Deutsche Bank**
Design: **Spin**
Colour overview:
Colour used to highlight key aspects of body copy and create a text hierarchy

[...] meaning-making can be compared to literacy: the reader must know how to [...] of signs confronting her – be they letters of an alphabet, the receding lines of conventional perspective, a pile of bricks or the taped monologue of a necrophiliac actionist in the Mexican desert. The narrative codes of the Renaissance were widely shared – the Bible provided a common framework for meaning, as did later texts such as Ovid's *Metamorphoses*. Classical literature. Pictorial codes were equally understood, whether the Byzantine distinctions of icon painting, or later representational mimesis. But beginning with the [...] press, and continuing to the development of the worldwide web, the [...] formation has increasingly undermined the ability to speak of a common visual language. If any single feature defines the post-modern world, it is the ubiquity [...] tradition. On the one hand, this means the near impossibility of uninterpreted [...] based contemporary art. On the other it means that it is the mass media – not the arts – [...] dominate the construction of the few cultural codes we share.

[...] Where does this leave us? With Joseph Beuys in the MMK, Puff Daddy on MTV, Marc Quinn at the Tate Modern, and Benetton posters in the Tube. We are overwhelmed by cultural information that crosses all boundaries – that hips, hops and scratches, but ultimately anaesthetises us into a state of waking somnambulism. We feel we need a new class of high priests to tease out the meaning. But has art become so marginalised and so impotent that it can no longer speak the language of its own time without simultaneous translation? Perhaps the way forward is not to try and define what art is, so much as how it is experienced. In this way, perhaps, the dimensions of both meaning-making and pleasure can once again find each other on a common ground.

_A recurring figure in children['s...] the shabby bearded figure wi[...] marvellous and wonderful thin[...] down the street, sharpening [...] was his collection of oddities [...] worlds as vivid as the far-off [...]

_What magic there was in co[...] rocks and oddly shaped thing[...] fasten down railway ties. His [...] stamps, baseball cards, and l[...] shelves as prized acquisitions [...] fleamarkets and jumble sales [...] of sniffing and snooping; of m[...] nascent connoisseurship – a [...] gave rise to the practice of m[...]

_What makes this engageme[...] Certainly collecting objects fo[...] oldest human practices. The [...] worshipped by primitive peop[...] inhabited by a spirit.' It has se[...] become a part of the psycho[...] Freud, and Marx before him, [...] and endowed with special pr[...]

_For Freud, the identification [...] for Marx, with the alienation [...] than the creative subject. The [...] responses to displayed objec[...] objects and to invest this wo[...]

4 Cooper-Greenhill op. cit. p.70

6 Bourdieu P and Darbel A. L'amour de l'[...]
Paris: Editions de minuit, 1969

_MMK / Puff Daddy on MTV / Marc Quinn

_Win[...]

—

_a sta[...]

somn[...]

5 James Elkins Why Are Our Pictures Puzzles?
Routledge, New York, 1999 p.24

7 Tanizaki, J In Praise of Shadows
New Haven: Leete's Island Books, 1977

d memory, is the rag-and-bone man –
-old singsong, and his assortment of
ummer morning, wending his way
ping to chat with passers-by. But it
, summoning up different and exotic
ter Rat in *The Wind in the Willows.*

hasures might be simple curiosities:
watch, or the heavy spikes used to
s became more knowing and directed:
n and chipped, were displayed on
and secret drawers. Still later,
trove. Collecting was a joyful process
cts to find the best one. It was a
on and discernment that, in many,

ies they can tell so compelling?
or fetishistic powers is one of the
sed to describe "an inanimate object
il magical powers or for being
rks of Freud and his followers –
exicon of the 20th century. Both
bjects become separate from people

ng sexual significance to the object;
ds and their 'reification' as other
d to a whole range of psychic
apacity to find magic in the world of

_We must, of course, be
cautious about too broad a
use of the word 'other.' All
social practices are
fundamentally relational,
says Bourdieu. "It is the
relation between the rules
themselves and the sense of
the rules that engenders the
issues and constitutes the
values, which, even while
they do not exist outside of
this relation, impose
themselves within it with a
necessity and an absolute
evidence. It is this original
form of fetishism that is the
principle behind all action."

_But another facet of our
relationship with objects lies
in the immediate
appreciation of them as
things that have been made
– for the instrumentality of
their making, and the sheer
joy of manipulation that must
still be resident, even as a
memory. "Joy was in every
ingredient of our making,"
says Kahn. "When the world
was an ooze without any
shape or direction, there must
have been this force of Joy
that prevailed everywhere

and that was reaching out to express itself." This is true of all
objects. We invest them with powers to the extent to which
we can participate in them: in their history, in their making –
in the intellectual and emotional process of reliving their
conception. Jun'ichiro Tanizaki speaks of the 'sheen of
antiquity' much prized by the Oriental cultures. "In both
Chinese and Japanese the words describing this glow
describe a polish that comes of being touched over and over
again, a sheen produced by the oils that naturally permeate
an object after long years of handling ... We love the colours
and the sheen that call to mind the past that made them.
Living in these old houses among these old objects is, in
some mysterious way, a source of peace and repose."

_It is precisely this type of engagement that is the
phenomenological keystone to the museum enterprise.
The visitor must be able to live through the objects he
experiences – they do not exist in a universe of their own;
they belong to a human world, a world of human actors.
There is no object that is not embedded in some language
with a system of rules for its own understanding. "One may
legitimately approach a work of ancient art as an object to
be deciphered, and attempt to elucidate its particular
language of artistic devices," wrote the celebrated Soviet
linguist and semiotician Boris Uspensky. But does not the
object itself give us some clues, like poetry, to its possible
reconstruction? It is now taken for granted that objects
from all cultures must be decoded in order to be
apprehended, let alone appreciated, in their fullness. But
what can we say about the deep delight the visitor draws
from delving into the object itself? Surely the joys of such
intellectual exploration are those same joys which fuel the
desire to create, to collect, and to see.

he Willows.

waking

ulism

Visuell

This spread is taken from *Visuell*, a book by the Deutsche Bank and about its art collection. Cyan pull quotes display text extracts, and the same text is also highlighted in yellow in the body copy. In a chapter that does not contain a single image, colour aids the creation of this visual design and helps express the textual hierarchy by isolating key elements of the content. For example, reference numbers are displayed in cyan and are accompanied by a magenta line that leads to the reference. These footnotes appear in different positions on the page, and in some instances are even placed on the following page.

Colour Hierarchy

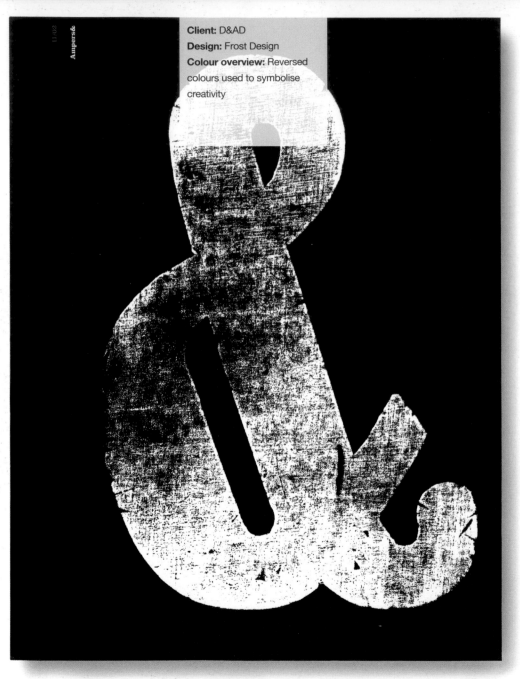

11/02

Ampers&

Client: D&AD
Design: Frost Design
Colour overview: Reversed colours used to symbolise creativity

Colour Symbolism

Colours possess a wealth of symbolic meanings that are derived from cultural and social associations. As such, those living in different countries and having different cultural values may vary in their reactions towards, and connotations with, the same colour. For example, in many Western countries red is a colour that is often associated with danger, but it can also suggest festivities if used in conjunction with gold – as these colours are often seen on Christmas cards and decorations. However, in many Eastern countries, red is a colour that suggests good fortune, wealth and purity. Similarly, in the West the colour that is most associated with death is black. However, in the East white is often used to denote mourning.

Colour selections must therefore be made in consideration of the cultural norms and associations of the intended target audience, particularly if a design is to be seen internationally.

D&AD (left)

This design is from a publication created by Frost Design for D&AD. It features a large-scale woodblock ampersand character that has been reversed out. The woodblock provides the character with a wonderful texture, which is lifted and amplified via the high contrast obtained by the reverse-out technique. A subtle hint of red warms the image and makes this contrast somewhat softer. We are accustomed to viewing this character printed in black and on a white stock. However, the reversed colours used here are symbolic of the creative processes' periodic need to turn the world upside down to achieve its ends.

Emotional reactions

Colour is a key design element because of its ability to elicit emotional reactions in the viewer. As a consequence colours are often described with emotive words such as 'cool', 'hot', 'calming' or 'exciting', and most colours are associated with particular adjectives. For example, red is generally a hot or exciting colour, while blue is cool and reserved, and we have all been green with envy at some point.

The tone of a design can change completely depending upon the colour palette used. A dash of bright red can get the pulse racing and energise the viewer, while a muted blue can relax the viewer, perhaps in preparation to read technical information.

However, different groups in society have different colour associations and responses. When attempting to provoke a specific response with a piece of work, a designer must take into account the fact that emotional reactions and instantaneous associations are likely to be culturally specific.

Colour Colour Symbolism

Into Another Light (right)

This packaging was created by Sagmeister Inc. design studio, on behalf of Enemy Records for the *'Into Another Light'* CD by Sonny Sharrock. As this was the last recording he made before he died the design features black packaging as a mark of mourning.

Client: Enemy Records
Design: Sagmeister Inc.
Colour overview:
Black used to denote
mourning

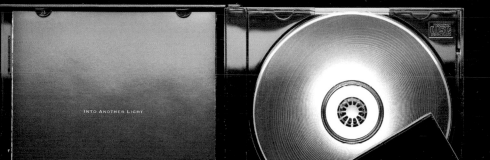

INTO ANOTHER LIGHT

Red

Red is the colour of fast sports cars, anger, summer berries, danger and blood. Research indicates that seeing red releases epinephrine in the body, a chemical that causes you to breathe more rapidly, and your heartbeat, pulse rate and blood pressure to rise. Red is an exciting, dynamic and energetic colour. It is passionate, provocative, seductive and stimulates various appetites.

When deepened to burgundy, red is more authoritative, refined and elegant. When diluted and softened into a rose or pink it is youthful, delicate and gentle.

Red can be used to great effect in order to direct a viewer's attention to specific aspects of a design, but because of its strength, red is a demanding colour to view, and as such, it can be a difficult colour to incorporate in a design. The use of red for extended pieces of text against a white background will tire the eye as it is not a calming colour, and in some quarters, red text is considered rude.

A Walk Through Books (right)

A Walk Through Books is a publication about the book-related work of London-based design studio Browns. The leatherette cover features a gold foil stamp, similar to that featured on many other books, but the choice and use of red leatherette subverts this classic book-finishing element, making its visual impact much more dramatic. The power of the red colour contrasts with the historic, conservative foil block image of London's Tower Bridge.

Client: Browns
Design: Browns
Colour overview:
Gold foil stamp used in
conjunction with red
leatherette to subvert
the norm

Pink

Pink is a warm, exciting, fun and feminine colour. It is a colour strongly associated with love and romance, and also with good health. As the amount of red in pink increases, it becomes more vivid and youthful, and with lower amounts of red, it becomes more delicate and mature.

Pink shades are a colour staple of the fashion and cosmetics industries because of their ability to convey femininity.

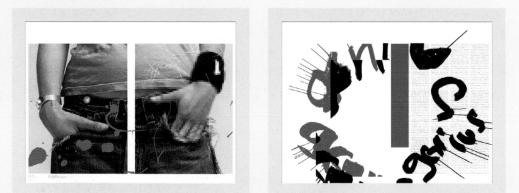

Genius 3 (above and right)

These spreads were created by Intro design studio for the Mat Cook book *Genius 3*. The book documents the global popularity of denim, and features a number of spontaneous and chaotic street-style images. Some of the photographs have been unexpectedly and randomly splattered with a fluorescent-pink paint, which echoes a graffiti-like style, specifically to grab attention and convey a sense of rebellious adolescence.

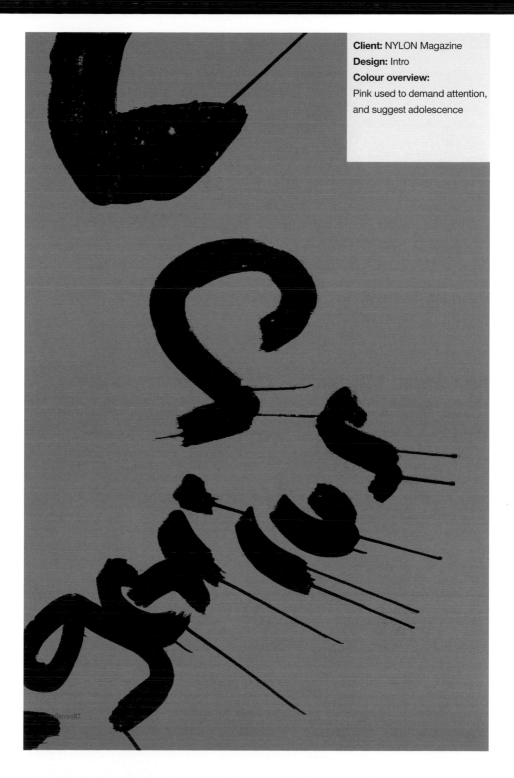

Client: NYLON Magazine
Design: Intro
Colour overview:
Pink used to demand attention,
and suggest adolescence

Colour Pink

Orange

Orange is considered one of the hottest colours. It is extrovert and playful, demanding attention, appealing especially to adolescents and young children. Its vital and flamboyant nature contains the passion of red, but it is calmed by the cheerful nature of yellow, and as such, it generally induces a feeling of warmth.

Orange has been found to stimulate the emotions and appetite, and for this reason it is frequently used in food-packaging concepts and signage designs. The warm feeling it produces brings thoughts of the changing seasons and the approach of summer, and also of good health through the association with the citrus fruit of the same name. Softer shades of orange are friendly and soothing and often used in food packaging to provide a delicious connotation of what lies inside.

Musica 13 (right)

This poster for an electro acoustic festival in Girona, Spain was created by Bis design studio. The festival features music made by objects, electronics and sound experimentation. Orange dominates the design because of its associations with Spain – perhaps because of the country's red and yellow flag, or the fact that Spain is a major producer of the orange fruit, or maybe even due to the clay roof tiles that adorn much of the rural architecture in Spain.

This simple design contrasts the block of orange colour with black and white typography, which provides a clear and powerful combination that maximises the visual statement.

Colour Colour Symbolism

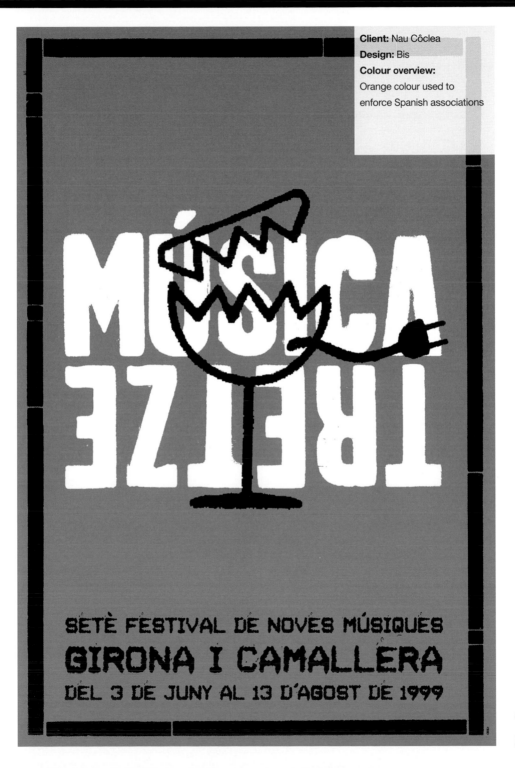

Yellow

Yellow is a bright and happy colour, reminiscent of warmer seasons and conjuring images that range from the intense vibrancy of sunshine and spring flowers, through to the golden hues of autumn leaves. Yellow is a versatile colour as it can represent many emotional states; bright yellows are often associated with vitality and happiness, while greeny yellows have a stronger connection to illness, nausea and disease. Equally pale yellows may create thoughts of citrus crispness, but can also signify cowardice depending on the context in which they are used.

When used together, yellow and black provide the highest contrast colour combination, and it is no coincidence that when these two colours are found together in the natural world they are often a warning mechanism; think, for example, of the colours of a stinging bumble bee or wasp.

Mankind has mimicked this colour-coding system and uses the scheme on a number of signs that warn of potential hazards and obstacles. Note the colour of the pillars in the example opposite that are not part of the design.

Client: East West
Design: Form Design
Colour overview:
Yellow background used to provide maximum contrast and visibility

187 Lockdown

This cover artwork for the music group 187 Lockdown was created by Form Design on behalf of East West. It features pre-printed plaques of the numerals '187' that are set in black against a vivid yellow background, and situated in various urban locations. The colour scheme of the oversized characters maximises contrast and therefore visibility and, given that they were placed in the urban environment, makes them appear incongruous.

Colour Yellow

Brown

Brown is a neutral, down-to-earth colour that is closely associated with the natural world via organic materials such as wood and stone. Brown is solid, dependable and conveys an impression of warmth and natural goodness; its wholesome appeal can be encapsulated by thoughts of freshly baked, warm, brown bread.

Brown is used to represent natural simplicity, outdoor life and the security of the home. Although brown is often viewed as a positive colour, it can also be associated with negative elements such as dirt and grime.

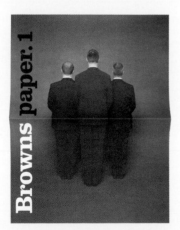

Browns Paper 1–3 (above and right)

This is a promotional brochure created by Browns design studio. The brochure has a broadsheet format and uses a brown colour scheme and a number of brown images as its central theme. The brochure conveys a down-to-earth approach, stability and longevity; all of which are key attributes of a successful design studio.

Client: Browns
Design: Browns
Colour overview:
Brown to suggest stability and
simplicity

Browns paper.03

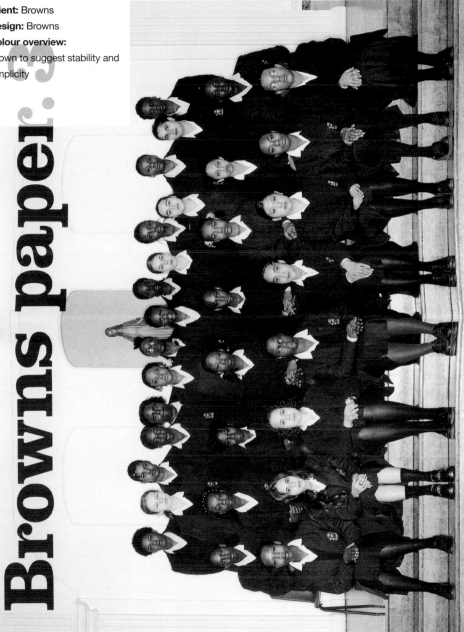

Blue

Blue is a colour that alludes to the mysteries and power of the natural world; it is the colour of the oceans and the sky. Blue has constant, vital, replenishing and life-preserving connotations through its association with water, and its effect is relaxing and calming. Blue is universally perceived as cool and cleansing.

Darker blues, such as navy, are considered conservative and uniform, which is why they are often used as corporate colours. They infer stability, security and trustworthiness. Pale blues suggest more youthful and serene qualities, while greeny-blues are associated with spirituality and mysticism.

Close Premium Finance Calendar (right)
This calendar was produced by Intro design studio for Close Premium Finance. Blue is selected as the predominant colour, signifying stability, solidity, authority and conservatism – characteristics that people trust and value in financial institutions. The use of the blue colour palette reinforces the association of these attributes and prompts the viewer to align them with the company.

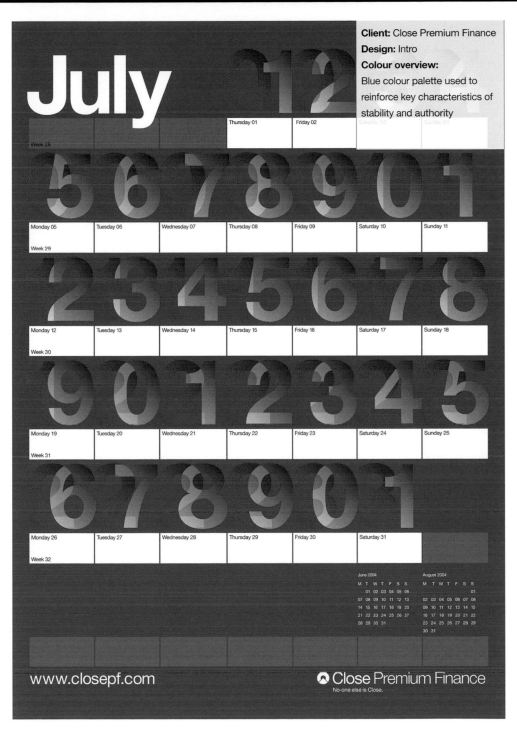

July

Client: Close Premium Finance
Design: Intro
Colour overview:
Blue colour palette used to reinforce key characteristics of stability and authority

Week 28

| Thursday 01 | Friday 02 | Saturday 03 | Sunday 04 |

| Monday 05 | Tuesday 06 | Wednesday 07 | Thursday 08 | Friday 09 | Saturday 10 | Sunday 11 |

Week 29

| Monday 12 | Tuesday 13 | Wednesday 14 | Thursday 15 | Friday 16 | Saturday 17 | Sunday 18 |

Week 30

| Monday 19 | Tuesday 20 | Wednesday 21 | Thursday 22 | Friday 23 | Saturday 24 | Sunday 25 |

Week 31

| Monday 26 | Tuesday 27 | Wednesday 28 | Thursday 29 | Friday 30 | Saturday 31 | |

Week 32

June 2004
M	T	W	T	F	S	S
	01	02	03	04	05	06
07	08	09	10	11	12	13
14	15	16	17	18	19	20
21	22	23	24	25	26	27
28	29	30	31			

August 2004
M	T	W	T	F	S	S
						01
02	03	04	05	06	07	08
09	10	11	12	13	14	15
16	17	18	19	20	21	22
23	24	25	26	27	28	29
30	31					

www.closepf.com

⬤ **Close** Premium Finance
No-one else is Close.

Colour Blue

Green

Green is a colour that embodies well-being, nature and the environment – reflecting verdant fields and forests. It is the colour of spring and therefore represents health, life and new beginnings. These natural associations mean that green is a peaceful colour and possesses calming qualities that give balance, harmony and stability.

People concerned about environmental issues are sometimes referred to as 'greens', and in the same vein the natural associations of the colour result in it being used on packaging material for a range of products to denote freshness or environmental friendliness.

Green is the colour most closely associated with Islam and is used on many flags of Islamic countries such as Saudi Arabia, Pakistan and Algeria.

Green can also be used to suggest negative connotations and, depending on the context in which it is used, can represent jealousy, envy and inexperience.

Indoor Garden Design (right)

This is a brochure created by Form Design for Indoor Garden Design. It features individual colour-coded sections, and each has a different shade of green similar to shades of green that one might find in a garden. The natural colour scheme reflects the subject matter of the brochure: garden design.

Indoor Garden Design Summersby Road T +44 (0)20 8444 1414 E office@igd.uk.com
Woodside Works London N6 5UH F +44 (0)20 8444 3414 W www.indoorgardendesign.com

INDOOR GARDEN DESIGN > CLIENT LIST

INDOOR GARDEN DESIGN > HOW WE WORK

INDOOR GARDEN DESIGN > AT WORK

INDOOR GARDEN DESIGN > CONTAINERS

INDOOR GARDEN DESIGN > SMALL PLANTS

INDOOR GARDEN DESIGN > LARGE PLANTS

Client: Indoor Garden Design
Design: Form Design
Colour overview:
Colour scheme reflecting
content and subject matter of
the brochure

Purple

Purple is a regal colour, which combines the hot tones of red with the cool tones of blue. It is an authoritative colour that denotes royalty, spirituality, nobility and ceremony. Its positive associations often include wisdom and enlightenment, but it can be used in a negative context to suggest cruelty and arrogance.

Purple is a colour that is often associated with people seeking spiritual fulfilment. It is a good colour to use if meditating as it is said to provide peace of mind and a calming influence. Purple is considered to be favoured by children and can assist the development of a child's imagination.

Donnachie (right)

This tone image was produced for *This Is A Magazine* by Studio KA design studio. The image is dark and grainy, but the soft and warm purple tones obliterate all details of the subject's face and her clothes, which suggests that something transcendental is occurring.

Client: This Is A Magazine
Design: Studio KA
Colour overview:
Warm purple tones to suggest
enlightenment

Colour Purple

Neutrals

Neutral tones are unobtrusive, classic and timeless because they are characterised by an absence of colour. Neutral colours are dependable, flexible and can be used to complement or pacify a wide range of stronger or more forceful colours. As neutrals are docile, they rarely provoke a strong reaction, insult or repel a viewer and therefore are widely used in design.

Within any design scheme, over usage or reliance on neutral colours may inhibit the intended communication of the piece, especially if no single element is sufficiently strong enough to stand out. However, neutrals do offer a good counterbalance to stronger colour sets; the catalogue cover shown on the opposite page has relatively neutral tones, but the inclusion of reds and oranges hints at the stronger colour schemes of the interior pages, a selection of which are shown below.

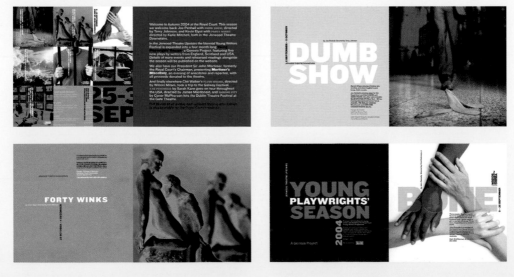

Client: Royal Court Theatre
Design: Research Studios
Colour overview:
Low contrast neutral colours

Royal Court Theatre (left and above)

This poster for London's Royal Court Theatre by Research Studios features a number of neutral colours that are relaxing and easy on the viewer's eye. The wood effect, neutral, brown background provides little contrast for the grey and orange text. However, the black text and large-point sized white text provide sufficient contrast so as to be prominent.

White

In the Western world, white is a colour associated with goodness, purity, cleanliness, simplicity and space; as such it is often associated with hospitals and medics, weddings and brides, and the divine or celestial. Conversely, in the East, white is recognised as the colour of mourning and is therefore associated with funerals and death.

White is a neutral colour that provides a good contrast for a number of strong colours including black, orange and blue . As such it can often be found both as the master colour and a contrast colour in monotone designs. A variety of white shades exist such as a peach white, which is friendlier; creamy white, which is more subdued; or blue white, which is perceived as cooler.

White space is a key layout element as it can help the eye to move between the different components within a scheme. Allowing large amounts of white space can also provide exclusivity or drama to a design

White is a difficult colour to print because any underlying colours will strikethrough. Fortunately, the predominance of white substrates means that it is possible to achieve this colour simply by not printing on the relevant area of the design or by knocking out other colours from a printed area.

03. El tiempo / Time

111.600

Santa Claus dispondría de 31 horas para dar la vuelta al globo terráqueo, es decir, ha de recorrer 150 millones de kilómetros en 111.600 segundos, con lo que su trineo iría a la extraordinaria velocidad de 985,7 km/seg, unas 3.000 veces la velocidad del sonido.

Santa Claus would have 31 hours to circle the Earth, that is to say, he has to cover 150 million kilometres in 111,600 seconds, which means that his sleigh would travel at the extraordinary rate of 985,7 km/sec, about 3,000 times the speed of sound.

05. La velocidad / Speed

985,7

Entre juguetes y renos el peso de todo el conjunto, sin contar con el trineo, sería de unos 704.025.000 kilos que viajarían sobrevolando a 985,7 km/seg y que generarían una increíble resistencia aerodinámica, parecida a la de una nave espacial cuando reingresa en la atmósfera.

Between toys and reindeer the total overall weight, not counting the sleigh, would be about 704,025,000 kilos, which, travelling at the reckless speed of 985,7 km/sec, would generate an extraordinary aerodynamic resistance, similar to that of a spaceship as it reenters the atmosphere.

Client: Summa
Design: Summa
Colour overview:
White and red used in
conjunction to provide
a seasonal theme

SIM-
PLEX
SIGI-
LLUM
VERI
*

Simplex Sigillum Veri (above and left)

This is a publication created by and for Summa design studio as a Christmas message for its clients. The plain cover has the title debossed into the white stock, and the interior pages are french folded and carry a few lines of red text. The predominance of white is reflective of the snow that is associated with the Christmas period in the northern hemisphere. The publication is akin to a fall of snow, across which the debossed text treads like footprints. Red is also a colour associated with the Christmas period, for example it is found in holly berries, the chest of a robin, or even Santa's robes, and when used in conjunction with white it enforces the publication's seasonal message.

Colour White

Black

Black is quite simply the negation of colour. In Europe and North America, black has traditionally been the colour most associated with death and mourning. It is conservative and serious, and yet sexy, sophisticated and elegant. Exclusive events are often described as 'black-tie' and important dignitaries almost always travel in black limousines.

Black suggests opulence and exclusivity more than any other colour, and so it is associated with a gamut of luxury goods and used heavily in their promotion. The gravitas of black is also associated with weight and solidity, as the colour offers an imposing and powerful presence. For automobiles, the advantage is that black cars are perceived to be solid and therefore safer. Conversely, commercial airliners avoid painting their craft black as people would perceive the aircraft as too heavy to fly.

When used in conjunction with white or yellow, black offers the strongest contrast of any colour combination and is consequently one of the most powerful. Black works well with most colours with the exception of other very dark colours.

Solid Air (right)

This invitation was created by Cartlidge Levene design studio for an exhibition hosted by the Crafts Council in London. The prism graphic was used as a simple visual metaphor to represent light, colour, reflection and refraction. Information about the event is embossed into the black substrate to create a strong visual hook and impact a sense of exclusivity. The suggestion of exclusivity is enhanced by the luxuriously glossy surface of the invitation and the rarity of this manner of presentation.

Client: The Crafts Council
Design: Cartlidge Levene
Colour overview:
Embossed black substrate
used to suggest luxury and
exclusivity

You are invite
view of Solid
10 April 2002 a
6 — 8pm
Entry by invitati
44a Penr
Lo

Client: Diesel
Design: KesselsKramer
Colour overview:
Single colour covers and
utilitarian graphics

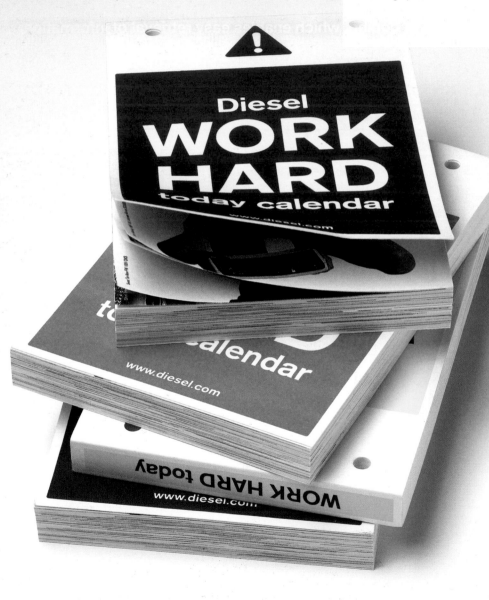

Colour is an integral part of many designs and often serves as a visual guide to its content. For example, using full-bleed printing on different sections and in various colours, can provide an immediate point of reference.

The ways in which colour can be applied in practice are numerous and diverse; what follows is intended not only to demonstrate how colour can be used as a hard-working design component, but also to provide inspiration as to how it might be exploited even further.

Work Hard (left)

In their design for a brochure to showcase various items produced by clothing manufacturer Diesel, KesselsKramer chose to use a hanging calendar format. The calendar contains 365 pages that display images and instructions which are themed around the title: 'Work Hard'. Each day presents a new instruction page such as 'stuff the backpack' or 'pull-up our socks', which can be detached when the day and the task is complete. The calendar was produced with four cover designs, each one was presented in a different colour and styled in a similar fashion to the warning signage you might see on a construction site.

Colour coding

In this context, colour coding is a means to organise different types of information so that the various groups of content are instantly recognisable, which helps us to quickly process the material we are viewing. Colour coding is widely used, for example it can be found on clothing labels (to indicate size), on traffic signs and even as a measure of national security status.

In these instances the type of colour coding used refers to a direct linear relationship between each of the coded items, but colour can also be used to provide abstract coding in order to establish a relationship between characteristics of the colour and the coded item. For example, green may be used in food packaging to denote freshness, but in detergent packaging it denotes that the product is environmentally friendly.

If colour coding is intended to provide a function, then the colours selected for the different items must be relevant. For example, a green label for a bottle of rat poison results in cognitive dissonance because the perceived characteristics for green (healthy and natural), conflict with the nature of poison (dangerous and harmful).

Fuse (right)

This is a stack of different issues of *Fuse*; a typography magazine founded by Neville Brody and John Wozencroft. The magazine's design was created by Research Studios and features a colour-coded sticker that seals the package. In this instance, the colour-coding serves only to distinguish different issues of the magazine and has no further meaning. However, the colour coding does provide the collected issues with a greater visual appeal.

Client: Fuse
Design: Research Studios
Colour overview:
Colour-coded sticker used to
identify different issues and
enhance visual appeal

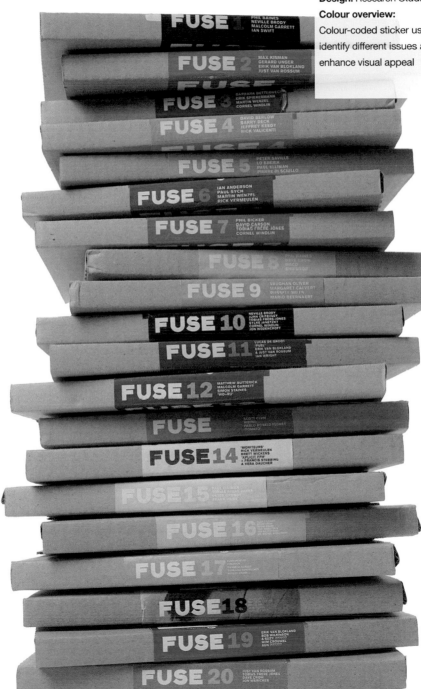

FUSE 1 — PHIL BAINES / NEVILLE BRODY / MALCOLM GARRETT / IAN SWIFT

FUSE 2 — MAX KISMAN / GERARD UNGER / ERIK VAN BLOKLAND / JUST VAN ROSSUM

FUSE 3 — BARBARA BUTTERWECK / ERIK SPIEKERMANN / MARTIN WENZEL / CORNEL WINDLIN

FUSE 4 — DAVID BERLOW / BARRY DECK / JEFFREY KEEDY / RICK VALICENTI

FUSE 5 — PETER SAVILLE / LO BREIER / PAUL ELLIMAN / PIERRE DI SCIULLO

FUSE 6 — IAN ANDERSON / PAUL SYCH / MARTIN WENZEL / RICK VERMEULEN

FUSE 7 — PHIL BICKER / DAVID CARSON / TOBIAS FRERE-JONES / CORNEL WINDLIN

FUSE 8 — PHIL BAINES / ...

FUSE 9 — VAUGHAN OLIVER / MARGARET CALVERT / RUSSELL MILLS / MARIO BEERNAERT

FUSE 10 — NEVILLE BRODY / JOHN CRITCHLEY / TOBIAS FRERE-JONES / SILKE SMETZKY / CORNEL WINDLIN / JON WOZENCROFT

FUSE 11 — LUCAS DE GROOT / 'FUEL' / ERIK VAN BLOKLAND & JUST VAN ROSSUM / IAN WRIGHT

FUSE 12 — MATTHEW BUTTERICK / MALCOLM GARRETT / SIMON STAINES / 'WD+RU'

FUSE — SCOTT CLUM / MORO / PABLO ROVALO FLORES / 'TOMATO'

FUSE 14 — 'MONTEURS' / RICK VERMEULEN / BRETT WICKENS / 'XPLICIT FFM' + FRANCIS STEBBING & VERA DAUCHER

FUSE 15 — PAUL ELLIMAN / TOBIAS FRERE-JONES / PETER GRUNDY / FRANK HEINE

FUSE 16

FUSE 17

FUSE 18

FUSE 19 — ERIK VAN BLOKLAND / BOB WILKINSON / & SUZY ?????? / WIM CROUWEL / AUS ??????

FUSE 20 — JUST VAN ROSSUM / TOBIAS FRERE-JONES / DAVE CROH / JON WARINCKER

Colour Colour coding

Client: Fig-1
Design: Bruce Mau Design
Colour overview:
50 special-process colours
used as colour-coded
identifiers on a collection of
posters

Fig-1

50 Projects in 50 Weeks is a book created by Canadian studio Bruce Mau Design and
is devoted to the Fig-1 project; a series of 50 exhibitions and events presented in a
small space in London that each lasted for a week. The book features 50 looseleaf A2
posters, each of which refer to the work of one of the 50 artists. Every poster is
printed in a different special-process colour (see page 36), which functions as a
colour-coded identifier for each artist. The different colours can be seen on the fore
edges of the pile of posters. All the special-process colours were combined and
used in the thread design of the first poster in the book, which can be seen sitting on
top of the pile shown.

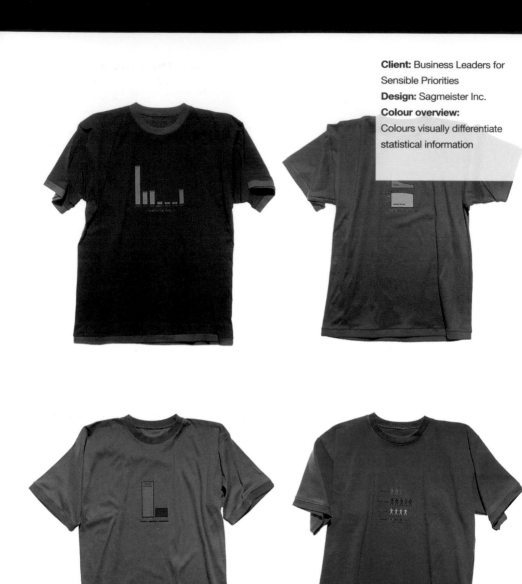

Client: Business Leaders for
Sensible Priorities
Design: Sagmeister Inc.
Colour overview:
Colours visually differentiate
statistical information

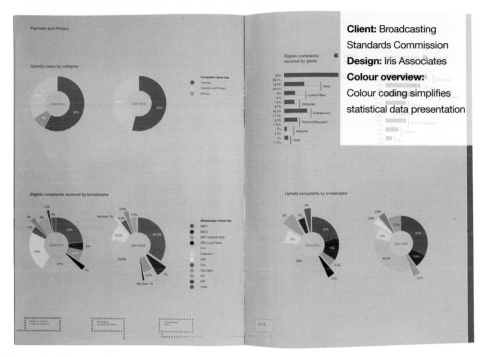

Client: Broadcasting Standards Commission

Design: Iris Associates

Colour overview:

Colour coding simplifies statistical data presentation

Move Our Money (left)

This design was created by Sagmeister Inc. for the Move Our Money campaign of Business Leaders for Sensible Priorities; an initiative by Ben & Jerry's co-founder Ben Cohen. More than 200 business leaders, CEOs and military advisers were assembled to lobby for a 15% reduction of the US military budget and a transfer of the funds to education and healthcare budgets.

For their part in the campaign, Sagmeister Inc. printed colour graphs on coloured t-shirts to illustrate the massive military spending of the Pentagon. The use of colour effectively conveys different aspects of the statistical information presented. The t-shirts, and the bright colours used, are associated with children and so are an effective mechanism to highlight the education and healthcare alternative for government expenditure.

Broadcasting Standards Commission Annual Review 2003 (above)

This is the UK Broadcasting Standards Commission's 2003 annual review, and it was created by Iris Associates design studio. The spread featured here presents data in bar charts and pie diagrams that relate to the review of complaints on fairness and privacy. The diagram shown top left uses three colours to identify the three different types of complaints, while the diagram shown bottom left uses several colours to identify a number of different broadcasters. Readers can tell at a glance how many complaints a particular broadcaster received and how many were upheld by the commission. In this way, colour coding provides a means of simplifying a large volume of complex data in a straightforward and easily-digestible manner.

Colour Colour coding

Colour as a warning

In the natural world, colour can provide an important form of alert: advertising danger. The bright colours of some species give predators a warning that they are likely to be unpalatable at best and poisonous at worst.

Red is a strong and stimulating colour. Red has high visibility, and is therefore often used on warning signs or as an alert to potential danger. When red is used in this manner, it allows the viewer to estimate the level of danger or risk and respond accordingly.

Less violent colours, such as blue, are more relaxing and is often used as a contrast to indicate that the danger has passed. The example shown on the facing page demonstrates how red and blue have both been used to enforce these associations of danger and safety.

Floodline (right)

This signage was created by North design studio for Floodline; a facet of the UK Environment Agency. The design uses a simple red and blue colour combination in conjunction with a range of symbols to represent the different flood warnings. Red is internationally associated with danger in our subconscious and so is an obvious choice for warning signs. The blue used for the 'all clear' sign is calming and this enforces the message that the danger has passed. Colour aside, the design of each symbol and sign is similar so that a link between them is easily established.

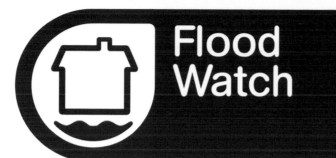

Client: Floodline
Design: North
Colour overview:
Colour used as a warning
system: red to indicate danger,
and blue for all clear

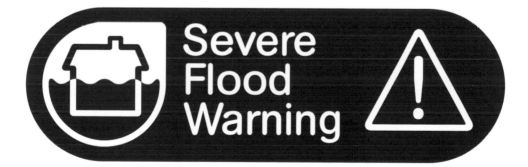

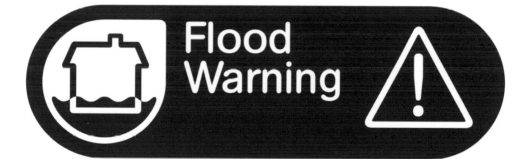

Colour Colour as a warning

Colour effects

A number of interesting graphic effects can be achieved within a design by use of optical illusions, which deceive the eye into perceiving something in a way that is different to its reality.

The positioning of different blocks of colour can affect our perception of size, or allow us to see movement in a static image, or make us believe that colours are lighter or darker than they actually are, or even completely different.

The clever positioning of blocks of colour will sometimes allow us to see 'after-images', which are actually remnants of a previously viewed visual stimuli.

Look at the black spot in one of these two coloured squares for about 30 seconds. Then immediately look at the black spot in one of the white squares. You should find that you can see an after-image which is relative to the colour of the original square.

Blue (right)

This promotional piece by New York design studio Sagmeister Inc. makes use of an optical illusion to highlight and reinforce the client's name – Blue. The design contains no blue colour, but through the use of an optical illusion it is created in the mind of the viewer, providing a very specific and unique message.

Client: Blue
Design: Sagmeister Inc.
Colour overview:
Use of an optical illusion to
create the colour blue in the
mind of the viewer

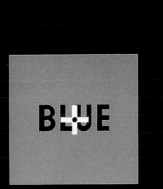

THIS COLOR IS BLUE!

Look at the small black point in the center of the cross in
the orange field for 20 seconds. Then look at the small
black point in the grey field. The orange field will appear
blue. And that's the way it's meant to be.

On Thursday 3.3.1994 we will open BLUE Clothing stores in Bregenz, Dornbirn, and Feldkirch.

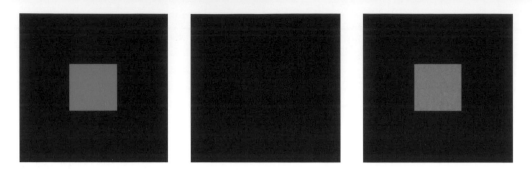

Effective colour selection can be used to control depth. Colours can appear to advance or recede, depending on the colour they are coupled with. Soft boundaries imply connection and therefore proximity, while distinct boundaries serve to separate the colours. The end result is that colours can appear to be positioned above or below one another.

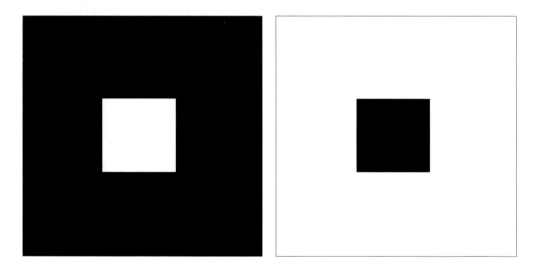

The choice of colour can also affect our perception of size. Brighter colours often appear to be larger than darker colours of the same size and shape. Notice that the small white square above looks bigger than the same-sized black square. The white boundaries spread into the black, which make it appear larger. Whereas the edges of the black square are flooded, making it contract.

Distance can be created by the size of the area that a colour covers. A large block of colour will reduce distance because the viewer's vision is flooded. Small areas of colour are less dominant and can appear to be further away.

In those instances where hues contrast, a vibrating boundary is created if these colours are juxtaposed. This gives a design a sense of movement, which can sometimes be uncomfortable on the eye, but can also be used to great effect as it can make a design leap off the page.

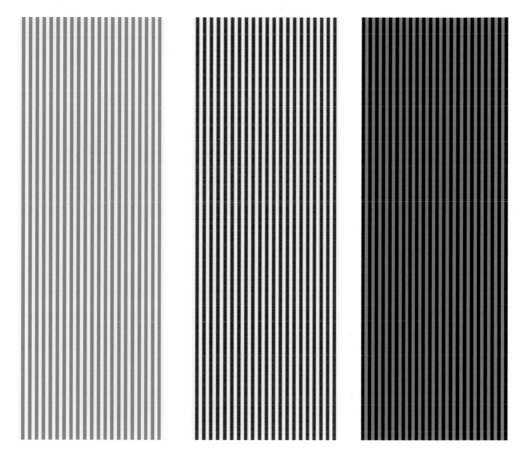

If you look at the block below you will notice that your eyes try to fill in the intersections of the white lines with the black of the small squares. The result is that you think you see grey squares at the corners of the black ones. This phenomena is called the 'blink' effect.

Creating Identity

Colour is often used to help establish a strong and instantly recognisable identity for a huge variety of organisations and their associated products or causes. Colour is used to condition and pre-empt the way in which people view the organisation or their associated produce or work. Dark blues are used to create conservative, dependable and trustworthy identities for banks and insurance companies; bright primary colours are used to create identities for children's products; and pink is often used to create identities relating to beauty, love and sex, as the example opposite shows.

Stage Beauty (right)

This is a brochure produced by NB: Studio for *Stage Beauty*; a film by Momentum Pictures. A vibrant magenta pink was used to begin and end the publication, which features stills from the film. The colour used conveys a sense of excitement and energy, youth and sexual overtones, and also creates an emotional identity for the film, which helps outline its subject matter. The ligature, or coupling, of the 'E' and 'A' characters in the word 'beauty' is a further reference to the sexual overtones of the film.

Client: Momentum Pictures
Design: NB: Studio
Colour overview:
Magenta pink used to create a
young and exciting identity

STAGE BEAUTY

STARSTRUCK, STAGESTRUCK, LOVESTRUCK....

IT'S THE 1660'S, AND ACTOR NED KYNASTON (BILLY CRUDUP) IS SITTING PRETTY; THE BRIGHTEST STAR IN RESTORATION THEATRE. WOMEN ARE FORBIDDEN TO APPEAR ON STAGE, SO THE BEAUTIFUL, BRAZEN, BISEXUAL NED SHINES IN ALL THE GREAT FEMALE ROLES. MARIA (CLAIRE DANES), HIS LOYAL DRESSER, LOOKS ON WITH ADMIRATION - AND JUST A TOUCH OF ENVY.

BUT SUDDENLY, NED'S WORLD IS TURNED UPSIDE-DOWN. CHARLES II IS KEEN TO SPICE UP THE THEATRE AND SEE HIS PERSUASIVE YOUNG MISTRESS NELL GWYN TAKE SOME APPLAUSE. SO HE CHANGES THE LAW, BANNING CROSS DRESSING MALE ACTORS, AND SENDING NED'S ONCE-GLITTERING CAREER INTO FREEFALL. REDUCED TO DOING DRAG TURNS IN A SEEDY TAVERN, NED IS FINALLY RESCUED BY MARIA, WHO BY NOW IS STARTING TO MAKE A NAME FOR HERSELF AS AN ACTRESS.

HAVING FOUND EACH OTHER, THEY FIND THEMSELVES. AND A REINVENTED NED MAKES A TRIUMPHANT RETURN TO THE STAGE AS MARIA'S LEADING MAN.

BILLY CRUDUP AND CLAIRE DANES JOIN A HOST OF BRITISH STARS IN A DRAMATICALLY DIFFERENT PERIOD ROMANCE.

Ligature

A typographical device that joins two or three letters in a single unit to prevent the interference certain character combinations create. Ligatures are formed by extending the crossbar or connecting the ascenders. Ligature derives its name from 'ligare', which is the Latin word for 'bind'.

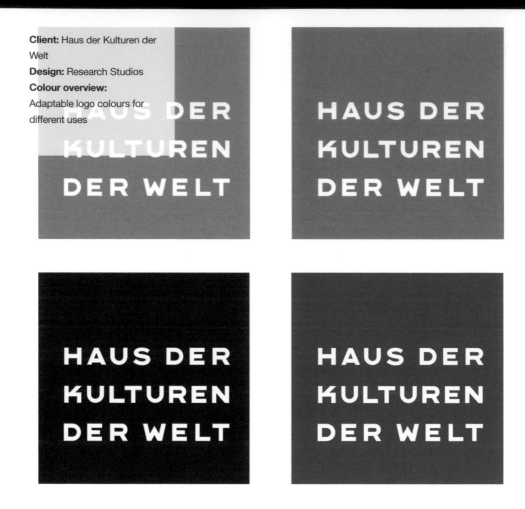

Client: Haus der Kulturen der Welt
Design: Research Studios
Colour overview:
Adaptable logo colours for different uses

Haus der Kulturen der Welt (above)

This is the hand-drawn logo that was created for the Haus der Kulturen der Welt cultural institute in Berlin. As well as providing an identity the logo was produced with an adaptable colour system that was used to identify the different activities and print requirements of the institute. The use of different colours for this logo hints at the breadth of cultural opportunities that the organisation offers.

Europees Kampioenschap Voetbal van Amsterdam (right)

This book was created by KesselsKramer for Het Parool, a Dutch daily newspaper. The book includes 16 portraits of people that are currently living in, or who were born in Amsterdam, and share a love of football. The verso page of each spread carries a full size photograph of the person wearing a replica shirt of the team they support. The colours of each shirt are mirrored on the facing page, which carries a statement from the person about their chosen team. The background colour reinforces their association with the different football teams.

Client: Het Parool
Design: KesselsKramer
Colour overview:
Colour used to reflect and
enforce team preference

VIOLA OLEVIA ARNON
UIT OOST

Verliet in 1990 Suriname en reisde naar Amsterdam, omdat haar kinderen hier ook al woonden.
Ging vroeger altijd naar de wedstrijden van de club Transvaal.
Nu volgt ze trouw Ajax, zij het via de tv.
Is een fanatieke fan van Oranje, want 'ik ben geboren onder de vlag van Nederland'.
Heeft geen echte favorieten, maar is natuurlijk trots op 'onze jongens Patrick Kluivert en Edgar Davids'.
'Zij ook in een clubje van de kerk, maar daar wordt niet over het EK gepraat.'
'Daar is alles van God, niet van voetbal.'

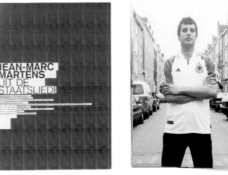

JEAN-MARC MARTENS
UIT DE
STAATSLIEDENBUURT

OLIVER HELLMANN
UIT WESTERPARK

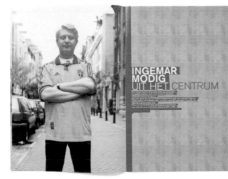

INGEMAR MODIG
UIT HET CENTRUM

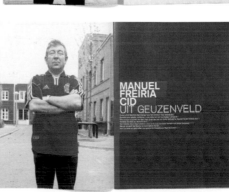

MANUEL FREIRIA CID
UIT GEUZENVELD

Colour Creating identity

Museon

This museum identity system was created by Dutch design studio Faydherbe / De Vringer for Museon. This spread shows how the colours incorporated in the design have also been used to extend the museum's identity on to a range of different products such as business cards, badges, posters and so on. Each item is characterised by corresponding colour-coding that originates from the Museon logo.

Ebbert Olierook

Producties

Tentoonstellingstechniek

 MUSEON

Stadhouderslaan 37
2517 HV Den Haag
Nederland

Postbus 30313
2500 GH Den Haag
Nederland

T: (070) 338 13 08
F: (070) 338 13 36
E: eolierook@museon.nl
I: www.museon.nl

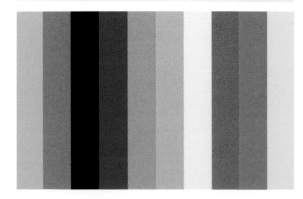

Client: Museon
Design:
Faydherbe / De Vringer
Colour overview:
Extension of logo colours to
provide consistent identity

Educatief Programma 2004 / 2005
Voortgezet onderwijs

MUSEON

Client: Orla Kiely
Design: Solar Initiative
Colour overview:
Reflect seasons and strong
colour content of fashion
designs

Orla Kiely

This promotional material was created by Solar Initiative design studio for fashion designer Orla Kiely. The colours used in the booklets and leaflets of Kiely's seasonal collections reflect the changing seasons. For example, browns are used for autumn / winter material, and reds, pinks and mauves are used in a floral design for the spring / summer material. The presentation of the content for both seasons is similar in order to provide consistency and reinforce the typically colourful identity of the fashion label. To maximise the impact of the colour, a glossy cast-coated stock was used and printed with high pigment inks to achieve strong colour reproduction.

Orla Kiely

spring / summer collection 2004

Cast-coated stock

A heavy, clay-coated stock that gives excellent colour reproduction. Whilst it is still wet, the coating is pressed (or cast) against a polished, hot, metal drum to produce a high-gloss finish, usually on one side of the sheet.

Colour Creating identity

Client: CRU
Design: Bis
Colour overview:
Monochrome treatment to
suggest sinister nature and
reflect gravity of subject matter

Client: Aufgabe Gestalt
Design: Bis
Colour overview:
Black inks for black sculptures

Aufgabe Gestalt (above)

This catalogue was created by Bis design studio to support an exhibition by Spanish sculptor Aufgabe Gestalt. Most of the pieces in the exhibition were constructed from black aluminium, black lacquered wood and other black materials. The catalogue is printed in five different black inks and as such the colour scheme for the publication reflects the sculptor's black on black approach, but as everything in it is also printed black on black the content is only visible if you move the book so that light picks out the different inks.

Violencia Sostenible (left)

This is a publication created by Bis for CRU art project *Violencia Sostenible*, which looks at the issue of violence. The text is supplied by artist Javier Peñafiel and graphics by Bis designer Alex Gifreu. The book comprises ten posters that are held together with a belly band. Each of the posters feature monochrome black-and-grey images, which are augmented with white, grey and black text to create a sinister and soulless impression. CRU is an independent company that produces books in collaboration with contemporary and compromised artists.

Client: Design Council
Design: Gavin Ambrose and Matt Lumby
Colour overview: Brand identity reinforcement through colour and style of objects

Design Council

These objects were created by Gavin Ambrose and Matt Lumby for the UK Design Council's *Design in Britain* installation. The installation transformed numerical facts on the contribution that British design makes to UK industry into physical manifestations. The large-format treatment of the figures not only corresponds to the importance of what the numbers are used to represent, but also breaks down a large amount of statistical data into more interactive and memorable iconography. The numerals reinforce the brand identify of the Design Council as they are produced in Helvetica Black type and in Pantone 485 red, both of which are in accordance with the Design Council's brand specifications.

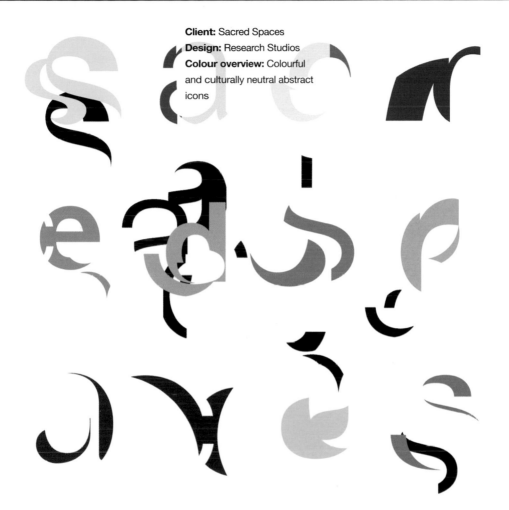

Client: Sacred Spaces
Design: Research Studios
Colour overview: Colourful and culturally neutral abstract icons

Sacred Spaces

The art collected for exhibition in the Sacred Spaces project aimed to revitalise traditional links between art and religion via a collaboration between artists, faith communities and schools, across 12 different places of worship in East London.

Research Studios created a colourful identity for the project and an abstract icon for each of the 12 artists / spaces involved, which was formed from the words 'sacred' and 'spaces'. The many colours used create an invigorating design that is appealing to children and yet avoids any single cultural connotations.

Colour Creating identity

Client: ING Barings

Design: Frost Design

Colour overview:
Careful selection of two
colours to suggest a secure
but progressive identity

In a word ING BARINGS

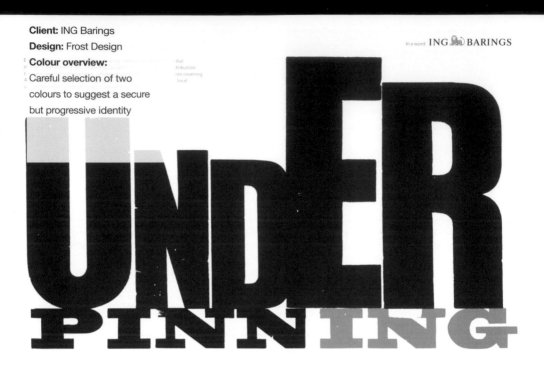

Colour Colour in Practice

ING Barings

These are promotional posters, which were created for ING Barings bank by Frost
Design. The posters feature continuous-tense verbs which are set so that they
visually represent the action the verb describes. The words are printed in a dark blue:
a conservative and stable colour that is frequently used for bank identities. However,
the 'ing' verb termination has been highlighted in a more dynamic orange, to clearly
identify it as the organisation's name. The colour scheme selected suggests that the
bank is secure but progressive.

Client: thecolourofwhite.com
Design: Intro
Colour overview:
Various methods of
reproducing white on white

The Colour of White
This book was produced by Intro design studio for thecolourofwhite.com,
to promote the launch of a new online art gallery. The book is entitled *The Colour of
White* and everything in it is reproduced in white; from the cloth-covered hardback
that is embossed with the title, to the French-folded pages and the printing. The
absence of colour creates a very dramatic visual statement by barely saying anything.
Shown here are the white, French-folded pages that carry white screen-printed text.

Colour Creating identity

This spread shows the French-folded pages produced from a silk-coated stock. The pages are embossed with the names of the different artists that are featured in the online art gallery. The depression of the emboss provides the only 'colour' in the design.

bill
jacobson

Emboss

An emboss is a design that is stamped, without ink, into a substrate via a metal die, which provides a raised surface. This technique is primarily used to give tactile qualities to a design, although it can also be a key visual element. A deboss employs the same technique but gives a recessed surface.

Glossary

Understanding the huge variety of colours that are available, and developing the ability to incorporate them within a design, requires a sound knowledge of the relevant technical terms and definitions used to describe them. This glossary defines some of the common terminology used when dealing with colour as well as some of the concepts that this terminology serves to portray. An appreciation and knowledge of these terms will facilitate a better understanding and articulation of the subject.

Some of the terms in the glossary refer to techniques that have been used in the production of this book: pages 33, 36–37, 40–41, 44–45 and 48 are printed with a special fluorescent ink; various overprints are found on pages 37, 44–45, 76 and 77, and a range of different paper stocks have been used.

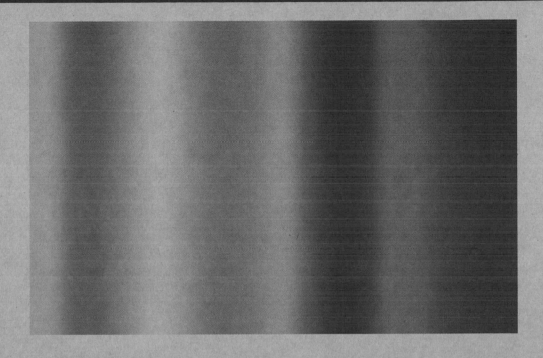

Hue

Hue is the colour reflected or transmitted from an object, and is expressed as a value between 0–360 on the colour wheel. The gradient fill shown above has a hue that oscillates throughout this range of values from 0 to 360.

Accent colour
A colour that provides a sympathetic visual detail.

Analogous colours
The two colours on either side of any given colour on the colour wheel.

Bellyband
A loop (or strip) of substrate that wraps around the 'belly' of a publication.

Bleed
A printed image that extends over the trim edge of the stock.

Bouncer
A registration problem that occurs due to the use of the black process colour. It can be resolved by underprinting other process colours.

Brightness
The amount of light used to produce the colour.

Channel
One layer of colour information for a picture. A RGB image has three channels, a CMYK image has four and a black and white image has one.

Chroma (see saturation)

BLACK

95 Helvetica Black

The names of some colours provide us with information about their physical qualities in addition to their literal meanings. The typeface 95 Helvetica Black (above) sounds like a heavy, dark type, even when it is printed in a different colour. In this instance, the colour has been added to the name of the typeface to help describe its weight.

CMYK

Cyan, magenta, yellow and black; the subtractive primaries and four process colours.

Colour fall

The pages in a publication that will print with a colour, particularly a special colour, in four-colour publications.

Colour separation

A photographic filtration process that divides the colours of a continuous tone-coloured original into constituent colours.

Colour space

The definition of a colour by its hue, saturation and value.

Colour systems

A framework within which colour is used. For example CMYK or RGB are two different forms of colour system.

Colour theory

Theory about the formation of, and relationships between, colour rules.

BLACK

25 Helvetica Ultralight

This typeface is Helvetica Ultralight, which is part of the same typeface family as the example on the opposite page. It is the opposite of a dark, heavy type and its use here in juxtaposition reinforces how using 'black' in the name of the typeface adds extra information.

Colour wheel
The colour spectrum formed into a circle.

Complementary colours
Those colours that face one another on the colour wheel. Also called contrasting colours.

Contrast
The amount of grey that an image contains.

Continuous tone
The continuous shades in an image, such as a photograph, which are not broken up into dots.

Dominant colour
The main colour used in a design scheme.

Dot gain
The spreading and enlarging of ink dots on a paper stock.

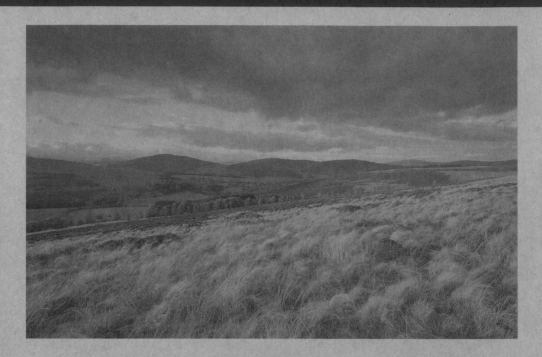

Invert

An invert is a very simple colour effect that turns even a simple image into something more dramatic. By inverting the colours, highlights become areas of darkness and shadow areas become highlights. The result, particularly for a landscape image such as the one pictured, seems to be from another world. Inversion also allows us to notice details that may have been overlooked in the original image.

Double complements
Any two adjacent colours on the colour wheel and their two complementary colours.

Duotone
A tonal image that is produced using two colours.

Emboss
A design that is stamped, without ink, into a substrate via a metal die to produce a raised surface.

Endpapers
Stock used for the outer pastedown and flyleaves at the front and back of a book.

Flaps
A physical extension of the cover.

Fluorescent colour
A vibrant special colour that cannot be reproduced by combining the process colours.

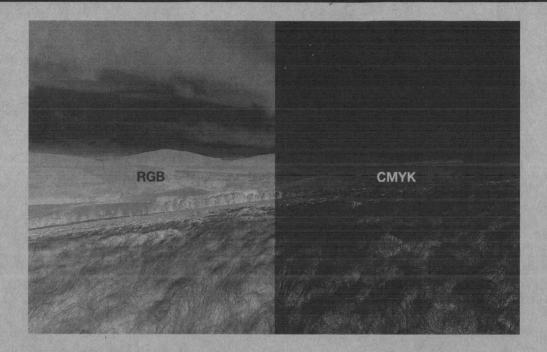

The effects of an inversion are dependent on the colour mode the work is done in. As can be seen above, converting in RGB mode gives a dramatically different effect to converting in CMYK.

Foil stamp
Metallic detailing that is applied with heat and pressure.
Fore-edge printing
A special printing process of the fore edge of a publication's pages; such as gilding.

Gamut
The spectrum of colours that a device or process can reproduce.
Gradients
An image fill that makes a transition from one colour to another.

Greyscale
An image that contains shades of grey as well as black and white. Also the brightness of a pixel expressed as a value representing its lightness from black to white.
Halftone
The simulation of a continuous tone produced by a pattern of dots.

blue-eyed boy
out of the blue
green with envy
white lie
grey matter
paint the town red
red tape
blue/white collar worker

in the red
black sheep
green fingers
see red
give the green light
caught red handed
purple prose
blue chip

Colour in Language

The English language contains many idioms. As the list above shows, a large selection of these are colour related. Although no true meaning can be understood from the individual elements of the phrase, the colour in the expression often hints at the intended meaning. The different associations we have made with each colour

Head and tail bands
Decorative cloth tapes that are applied to protect the top and bottom of a book's spine.

Hierarchy
A logical, organised and visual guide for text headings within a design scheme.

Hue
The colour reflected or transmitted from an object. Expressed as a value between 0–360 on the colour wheel.

Imposition plan
A diagram of the arrangement of pages in the sequence and position in which they will appear when printed before being cut, folded and trimmed.

Ink trapping
Overlapping of coloured text or shapes to account for printing misregistration and to prevent the appearance of white gaps.

Levels
The amount of colour present within a channel.

tickled pink
red herring
feeling blue
white noise
red raw
blackout
blue blooded

rose-tinted glasses
red-hot news
scream blue murder
once in a blue moon
shrinking violet
scarlet lady
yellow belly

have been absorbed into our language, so they are frequently used to reinforce the emotion or mood someone is trying to convey.

Metallic ink
A special printing ink that gives a gold, silver, bronze or copper effect.

Minimalism
A school of abstract painting and sculpture that emphasised extreme simplification of form and severely restricted the use of visual elements such as colour.

Monochrome
An image made of varying tones of one colour.

Mutual complements
A triad of equidistant colours and the complementary colour of the central one on the wheel.

Near complements
The colour that is adjacent to a complementary colour on the wheel.

Overprint
Describes two elements that are printed one on top of the other, usually a darker colour is printed over a lighter colour.

Tints and Shades

The colour wheel is based on pure colour. Every pure colour also has lighter and darker versions of it. Lighter versions are called tints and are produced by adding white. Darker versions are called shades and are produced by adding black.

Pagination
The arrangement and numbering of pages in a publication.

Pantone Matching System (PMS)
A colour matching system.

Primary colours
There are two types of primary colours: additive and subtractive. Additive primaries are colours obtained by emitted light, and subtractive primaries are those produced by the subtraction of light.

Reverse out
The removal of part of a flood colour in order to leave white space.

RGB
Red, green and blue; the additive primary colours.

Saturation
The colour variation of the same tonal brightness, from none to pure colour. It is the strength, purity or the amount of grey in relation to the hue.

Secondary colour
A colour produced from any two primary colours in equal proportions.

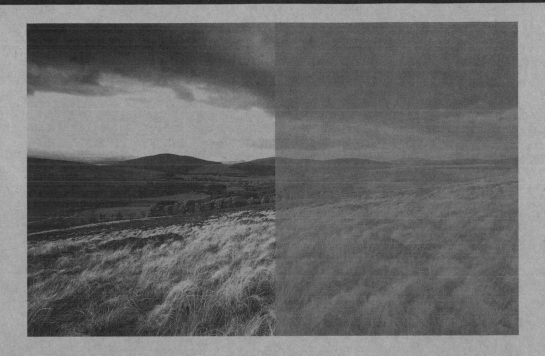

Contrast

Quite simply, contrast is the difference between colours. For example, black and white create the highest contrast possible. Colours can contrast in hue, value and saturation.

Section (or signature)
A sheet of printed stock that is folded to form several pages, usually eight or 16. Sections are collected together for binding.

Shade
A colour that is diluted with a little white.

Shiner
The addition of cyan underprint in order to improve the visual density and saturation of black.

Special colours
A specially mixed colour. Also called spot colour.

Split complements
Three colours on the colour wheel, comprising a chosen colour and the two adjacent colours of its complementary colour.

Stock
The material, usually paper, which is to be printed upon.

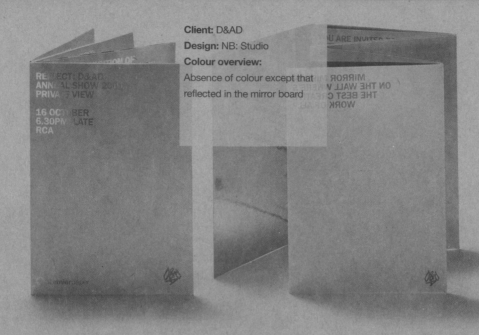

Client: D&AD
Design: NB: Studio
Colour overview:
Absence of colour except that reflected in the mirror board

D&AD

This invitation for D&AD's XXII annual show was designed by NB: Studio, and is constructed from mirror board. It has an absence of all colour except for that which is reflected in the mirror board from the surrounding environment. This results in a very clean and neutral design. Reversed text is printed in silver so that it can only be read when its reflection is viewed in the mirror board substrate.

Subordinate colour
A visually weaker colour in a colour scheme, which complements or contrasts with a dominant colour.

Substrate
A surface to be printed upon.

Surprint
Describes two elements that are printed on top of one another and are tints of the same colour.

Tertiary colours
Colours with an equal mix of a primary colour and the adjacent secondary colour on the colour wheel.

Tint
A colour that is predominantly white.

Tonal images
Images produced using black and one of the other process colours.

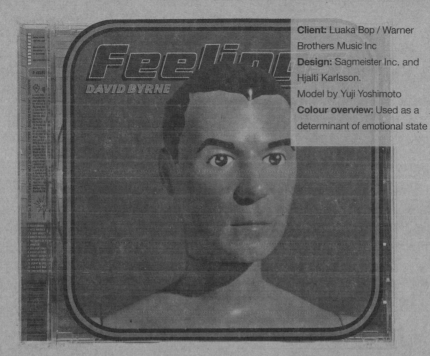

Client: Luaka Bop / Warner Brothers Music Inc
Design: Sagmeister Inc. and Hjalti Karlsson.
Model by Yuji Yoshimoto
Colour overview: Used as a determinant of emotional state

Feelings

The cover of David Byrne's CD 'Feelings' was created by New York designers Stefan Sagmeister and Hjalti Karlsson, and features a model of Byrne that was created by Yuji Yoshimoto, and then photographed for the cover artwork. The synthetic representation of the singer is shown in four different mood states and the CD packaging includes a colour coded 'David Byrne Mood Computer', which allows the user to determine their emotional state.

Tonal value
The relative densities of tone in an image.

Triads
Any three colours that are equidistant on the colour wheel.

Value
The depth or intensity of a colour as determined by how much white it contains.

Varnish
Coating applied to a printed sheet for protection or appearance.

Conclusion

This book explains the basic design principles and methodologies used when incorporating and selecting colour. A thorough understanding of how colour is reproduced, be it for screen or print, and a knowledge of its inherent meanings, will equip the designer with the ability to use colour successfully within a design scheme. A thorough understanding of these basic principles, together with knowledge of format, layout, typography and image, provides the designer with powerful tools that will allow tremendous creativity to be unleashed.

The use of colour has a marked impact on a design scheme, and is arguably more immediate than any other single element within a design. Used in conjunction with thoughtful layout, considered typographic treatments and ingenious image usage, colour not only enhances a design, but it can also distinguish it from its contemporaries.

We hope this book proves to be a useful reference when considering how colour can be integrated, manipulated and used to enhance a design. This book should be thought of as a starting point in an exploration of colour. The adventurous use of colour requires experimentation, considered thought and inevitably the odd mistake; but armed with the examples and contributions collected together in this volume, you should develop a clearer understanding of how this complex subject fits together.

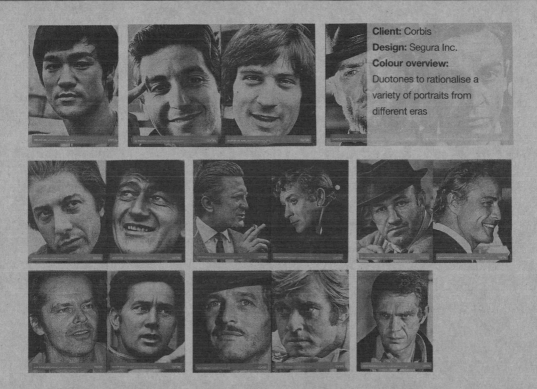

Client: Corbis
Design: Segura Inc.
Colour overview:
Duotones to rationalise a
variety of portraits from
different eras

Corbis

These images are taken from a catalogue that was produced for Corbis image library
by Segura Inc. The catalogue contains duotone images of film stars in which the
lighter tones have been replaced with a golden yellow. Some of the images used may
have originally been black-and-white photographs, whilst others may have been four
colour, however, the use of a duotone is a simple way to give all the images an equal
appearance and weighting, which might not have been the case had they been used
in their original form.

Client: Fuse
Design: Neville Brody and contributing designers
Colour overview:
Monotone absence of colour gives focus to design

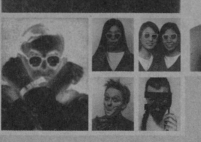

Alphabet

Acknowledgements

We would like to thank everyone who supported us during the project including the many art directors, designers and creatives who showed great generosity in allowing us to reproduce their work. Special thanks to everyone that hunted for, collated, compiled and rediscovered some of the fascinating work contained in this book. Thanks to Xavier Young for his patience, determination and skill in photographing the work showcased in this book, and to Heather Marshall for modelling. And a final big thanks to Natalia Price-Cabrera – who devised the original concept for this book – Caroline Walmsley, Renée Last, Brian Morris and all the staff at AVA Publishing who never tired of our requests, enquiries and questions, and supported us throughout.

Fuse (left)

This design is taken from an issue of typography magazine *Fuse* and was created by Neville Brody and various contributing designers. The design uses various images that give a visual impression of different letters: a hairstyle for 'p', a cup of tea for 't' and so on. Colour does not play a direct role in the communication of the design's central idea, however, the monotone presentation helps the viewer discard the interruption of colour aspects and, in this instance, focus on what the design is attempting to say.

Praise for Chloe Neill's Heirs of Chicagoland series

'Elisa is a fierce and endearing heroine readers will root for. This urban fantasy is a treat' *Publishers Weekly* on *Wicked Hour*

'Chloe Neill delivers yet another phenomenal urban fantasy tale . . . a must-read author for urban fantasy fans'
Fresh Fiction on *Wicked Hour*

'Fans of Neill's Chicagoland Vampires series will rejoice to see the next generation in their spin-off. Featuring her trademark snarky characters and colorful backgrounds, this is a fun and action-packed urban fantasy launch'
Library Journal on *Wild Hunger*

'The pages turn fast enough to satisfy vampire and romance fans alike' *Booklist*

'Chloe Neill introduces a wonderful new series with some fantastic characters . . . a great start to a terrific urban fantasy/ paranormal series' The Reading Café on *Wild Hunger*

'If you loved Nancy Drew but always wished she was an undead sword-wielding badass, Merit is your kind of girl'
Geek Monthly

'Neill's Chicago is an edgier, urban Bon Temps'
Heroes and Heartbreakers

'One of my all-time-favourite vampire series . . . It's witty, it's adventurous, there's political intrigue, murder, magic, and so much more' *USA Today*

'Action, supernatural politicking, the big evil baddie with a plan, and, of c Chicago-
land Van

Fantasy

By Chloe Neill for Gollancz:

Heirs of Chicagoland series
Wild Hunger
Wicked Hour
Shadowed Steel

Chicagoland Vampires series
Some Girls Bite
Friday Night Bites
Twice Bitten
Hard Bitten
Drink Deep
Biting Cold
House Rules
Biting Bad
Wild Things
Blood Games
Dark Debt
Midnight Marked
Blade Bound
Howling for You (eBook only novella)
Lucky Break (eBook only novella)
Phantom Kiss (eBook only novella)
Slaying It (eBook only novella)

Dark Elite series
Firespell
Hexbound
Charmfall

Devil's Isle series
The Veil
The Sight
The Hunt